NEW HAMPSHIRE
A LIVING LANDSCAPE

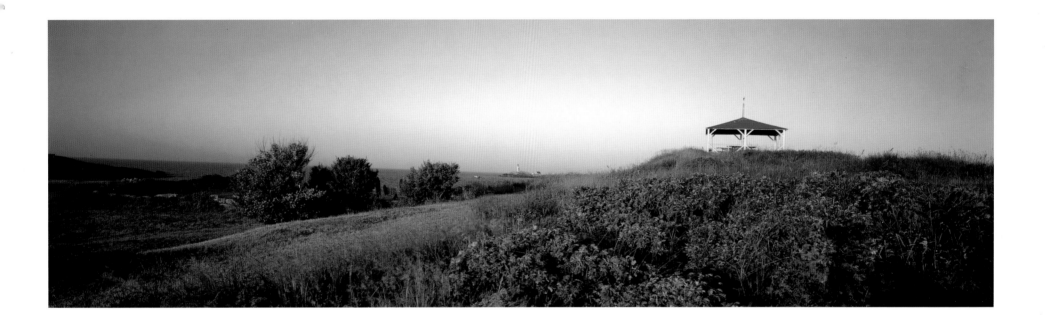

Society for the Protection of New Hampshire Forests

Since 1901, the Society for the Protection of New Hampshire Forests has helped conserve nearly one million acres of our beautiful state, including many of the landscapes captured by Peter Randall in this extraordinary publication. A nonprofit membership organization, the Society works as an environmental advocate, a land trust, and a forestry association with equal intelligence and vision.

The Society's vision of New Hampshire is of a living landscape, where working woods and protected lands are woven into the fabric of life. We envision beautiful forests growing high-value wood products, providing jobs and recreation, and protecting habitat for native plants and animals. We see wildlife, river, and trail corridors connecting scenic natural areas with carefully managed forests and farms. We see new partnerships promoting economic incentives, enlightened public policies, and responsible private action.

To achieve this vision, we have an exciting and innovative agenda for the 21st Century. To learn more about the Society and our "Living Landscape Agenda," please write or call:

Society for the Protection of New Hampshire Forests, 54 Portsmouth Street, Concord, NH 03301. (603) 224-9945.

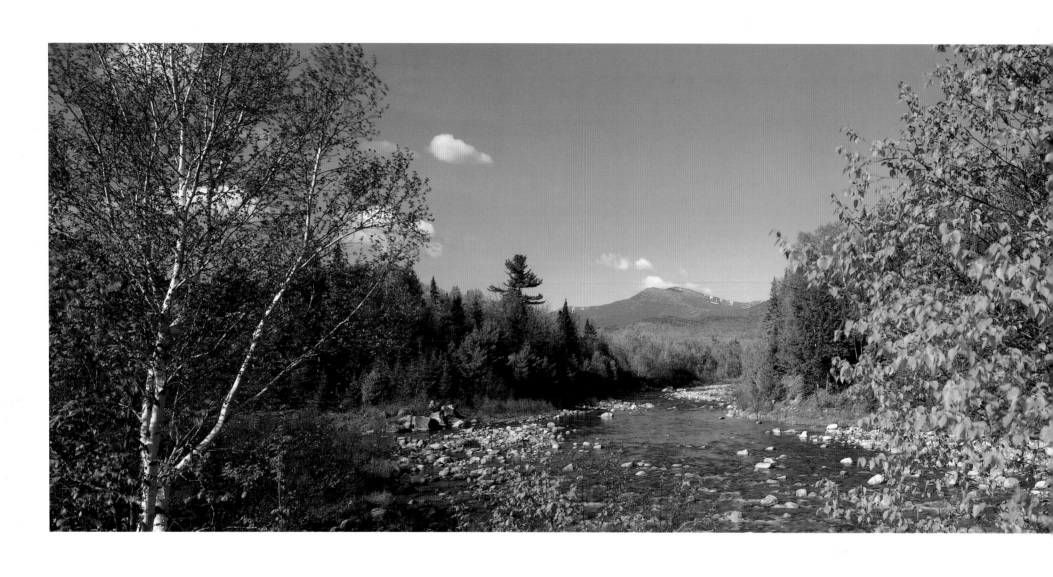

The publication of this book was made possible in part by a generous grant from
Fisher Scientific International Inc.
in cooperation with the Society for the Protection of New Hampshire Forests.

NEW HAMPSHIRE
A LIVING LANDSCAPE

Panoramic Photographs by

Peter E. Randall

Essay by Ronald Jager
With a Foreword by Stephen H. Taylor

Peter E. Randall Publisher

Portsmouth, New Hampshire

1996

For Sylvia and Kael, the fourteenth generation

ACKNOWLEDGMENTS

Books don't happen by themselves, nor do they result from a single burst of creative energy. When I began to use a panoramic camera in 1991, after some 30 years of photography, it seemed it was because I was finally ready to do so. Therefore, many people over the years have contributed, have helped me create this book. My late mother, Virginia, fostered my enjoyment of art; Richard Merritt was patient and supportive of my first photographic efforts; Sam Abell provided friendship and a mentor's critical eye; Gary Samson's contributions are many, ranging from his technical expertise and willingness to share his vast knowledge to his humor and first-rate traveling companionship; Herb Smith believes you can do whatever you want to do and proves it by doing it himself, thereby giving you the confidence to keep on trying; Pete Ballou nurtured my career by publishing my first photographic books; Joe and Jean Sawtelle's love and support are boundless; and my wife, Judy, who once again has had to share me with a camera and a state we both love.

More recent support has come from Paul Bofinger and Richard Ober of the Society for the Protection of New Hampshire Forests, and John Dionne and Spencer Stokes of Fisher Scientific International Inc., whose generous financial contribution helped to turn this five-year photographic project into a book. Directly contributing to this book were Frank DeLuca and the crew of Mandarin Offset; marketing wizard Jock Brodie; Ronald Jager and Steve Taylor, expert editor Kathy Brandes, and designer Tom Allen. To one and all, and to those whose names may have slipped from my memory but not my heart, I am truly grateful.

— P.E.R.

Peter E. Randall Publisher
Box 4726, Portsmouth, New Hampshire 03842

Half title page: *Rosa Rugosa, Star Island, Isles of Shoals*
Frontispiece: *Mt. Washington and the Peabody River, Gorham*

Photographs in this book are available for purchase by contacting the publisher.

Foreword

For more than a generation, earnest, well-meaning people have been bemoaning the development and urbanization of New Hampshire's most-scenic places and views. Our heritage of natural beauty is rapidly disappearing, they tell us, as the land is altered for residential and commercial use. And they are correct — to an extent.

Peter Randall shares the deep concern about the ongoing changes in New Hampshire's landscape, but he also knows that a wealth of places and views remain unspoiled by the shifts in land-use patterns that have occurred since World War II.

Throughout his life, he has sought out those special places and views and captured them on film. His enormous archive of slides and photographs has become an important and vital piece of the state's historical record.

Peter Randall brings to his New Hampshire photography a deep affection for and keen understanding of the state, its natural environment, and the idiosyncrasies of its people and culture. He has visited virtually all its villages, driven thousands of miles of back roads, climbed dozens of mountains, and canoed many streams and ponds.

He has risen in the dark to find the meadow mists of dawn at a remote farmstead and waited for the sun to light an autumn-hued sugar maple quaking in the afternoon breeze. Many of his images are fleeting glimpses of seasonal change, others are careful studies of the quietude of the wild; all reflect artistic skill and great diligence.

The photographs in this book reflect the diversity and complexity of the state's landscape, and especially the fascinating interplay of forests, fields, waters, and built features that make the New Hampshire countryside so appealing. It is a work meant to be enjoyed today, and it is certain to be valued and appreciated for many years to come.

It shows that while New Hampshire has been changing — and will continue to change — fortunately much remains as it has been.

Stephen H. Taylor, Commissioner
New Hampshire Department of Agriculture
May 18, 1996

Landscapes of Memory

BY RONALD JAGER

We know it as a living landscape, stern and lovely now, but it was scarcely alive at its birth. Ages and ages ago, New Hampshire granite was smelted deep within the earth in fires of incredible heat; afterward, when the molten granite had cooled to taffy and then hardened to rock, when its surface had been weathered and worn down for millions of years, it was reshaped again by repeated scourings of glacial ice. From the first, granite was ordained to be the foundation of every future landscape in New Hampshire. Green Mountain State to the west of us, Pine Tree State to the east of us, state of everlasting granite beneath us.

What a wonder, then, that after the eons of fire and ice had come and gone, there should appear in the north the Old Man of the Mountain, an aging human profile, gray and handsome.

This most famous signature of the state is composed of massive slabs of cracked and seamy granite; and it juts from a mountainside, brow in the clouds, high over Profile Lake in Franconia Notch, there confronting us head-on with Man and Nature — not just face-to-face, but *in* the same face. The Old Man is now probably ten or twenty thousand years old, and his business today, let us suppose, is to make vivid what we already know: A human presence broods upon this land. His hand — which is our hand — is everywhere and upon everything, and time and chance are unlikely to lift it from the landscape. It is a landscape now very much alive, full of memory and always new, forever held in tension between the urgency of human history and a legacy of natural grandeur.

How heavy or gentle, how callous or caring is our hand? How comely the results? Turn the pages of this book and see.

This book is a wide-eyed invitation to reflect on how these landscapes came to be ... came to be ours ... came to be loved ... came to be photographed. It happened in stages.

In the beginning, of course, was granite. It is underneath us and around us, and it sticks out randomly from our hills and mountains; and granite is the stuff of our main buildings — State House and prison, historical society and library, factory and warehouse. Granite forms the lining of all our rushing riverbeds, and granite, much subdivided, gives us thousands of miles of photogenic stone walls. There is granite in our fields and in our front yards, in our foundations and in our curbstones and hearthstones. And in our photographs. It is as common as air, commoner than water. Though we deal with it all the time, hardly anybody knows much of anything about granite, really — except that, well, there it is: hard and durable, not easily moved or worn out. And the supply is undepleted.

New Hampshire has been known as the Granite State since about 1830 — just the time when it became profitable to dig it out, slice it up, and sell it. Entire buildings — not just in New Hampshire, but in Boston, New York, Washington — were cut piece by piece out of Rattlesnake Hill near Concord, then floated on barges down the Merrimack and out to sea and into Atlantic seaboard harbors. They say that some of us, natives and heirs of the long agrarian traditions of this place, whose ancestors struggled lifelong with this hard and stubborn stuff, may have taken on its characteristics — granite integrity, rock-ribbed conservatism, immobility. Should we flatter ourselves if there is granite in our souls?

After granite came wilderness. On such a rockscape as this, the forest that sprang up to soften the surface inevitably took on a wild and forbidding character. But *wilderness*, unlike *granite*, is a historical term, and its meaning shifts with different times, different expectations and experience. When Europeans first ventured beyond the coastal plains and beheld the forest primeval rooted in this granite, they were daunted by a howling wilderness — a favorite descriptive term of the time. Englishman John Josselyn climbed a peak in the White Mountains in the seventeenth century and saw that "the country beyond the Hills Northward is daunting terrible, being full of rocky Hills as thick as Mole-hills in a Meadow, and cloathed with infinite thick woods." What had he seen? He had gazed upon infinite thick woods all right, and upon about twenty rocky mountainous peaks poking up above the tree line all the way to the northern horizon. If in his mind he makes these mountains into molehills in a meadow, he still finds them "daunting terrible." In his day, the forested wilderness was not a friendly place; it had little to do with beauty, grandeur, or recreation, and nothing to do with conservation. The howling wilderness was an adversary to be endured and tamed.

After wilderness came human habitation. Native Americans had lived with the wilderness for thousands of years before the Europeans arrived. We know the New Hampshire tribes as Abenakis and, according to legends about them, they were at first reluctant to convey the seacoast lands to the English intruders, those oddly dressed and pale-faced strangers who had just floated in one day, like driftwood from the sea. Abenakis did not think they owned the land, or that it could ever be traded or bought or sold. Similar reports come from other tribes in other places; it is a not-uncommon story. For these people, the land was simply available, like sunshine and air, like granite and river: It was not a commodity, not for sale. The Englishmen who, it is said, brought civilization to these shores, did not really understand such foreign metaphysics at all; what they understood was commodities and business. So they got the land. Forthwith began major changes in the landscape.

It is not hard to see from a distance of a few hundred years that New Hampshire's early viewers projected their feelings into the panoramas before them, seeing the vast new world by the light of their own European yearnings or forebodings. But, of course, we do the same — we cannot escape it and need not try — though we notice it less clearly in ourselves. The photographer who created the wonderful images in this book and the viewer who appreciates them are both mental heirs to a favored tradition, distinctive to this state and its long history. That historic tradition plays upon our memories and enters

these photographs: enters through the camera, enters through our minds.

As the colonists' experience shifted, so did perspectives of the landscape. In 1784, New Hampshire historian Reverend Jeremy Belknap headed a scientific party bent on climbing Mount Washington — then known as the Great Mountain or Agiocochook, its Indian name. Belknap didn't make it to the top himself (just too rotund to finish the climb), but, hailing from the well-settled coastal regions, he had a good eye for dramatic scenery, and nothing that met his gaze seemed daunting terrible. What he saw was sublime and beautiful. And what he wrote in *The History of New Hampshire* signals the beginning in America of romantic appreciation of mountainous scenery. With a penstroke he banished the daunting howling wilderness and, in rhetoric that set the tone for the next hundred years, he sketched a far fairer view:

These vast and irregular heights, being copiously replenished with water, exhibit a great variety of beautiful cascades; some of which fall in a perpendicular sheet or spout, others are winding and sloping, others spread, and form a basin in the rock, and then gush in cataract over its edge. A poetic fancy may find full gratification amidst these wild and rugged scenes, if its ardor be not checked by the fatigue of the approach. Almost everything in nature, which can be supposed capable of inspiring ideas of the sublime and beautiful, is here realized. Aged mountains, stupendous elevations, rolling clouds, impending rocks, verdant woods, crystal streams, the gentle rill, and the roaring torrent, all conspire to amaze, to soothe and to enrapture.

Perhaps people had felt it — this mountainous conspiracy "to amaze, to soothe and to enrapture" — but nobody in America wrote of it that way until Jeremy Belknap confronted the spectacle of the White Mountains. Europeans, with the recent discovery of the Alps as aesthetic objects, had just begun to feel and think and write in this manner. But now the times were right, and early in the nineteenth century, many Americans picked up the Belknap refrain. Some reached for biblical imagery to communicate a heightened sense of nature; some began to see the promise of the American dream in terms of a natural paradise — opulent, innocent, wild — and to find in New Hampshire vistas the locus of that promise. Were not its mountains the most impressive and biblical? Had not its valleys been made to bloom like an Eden? In a word: American nature became Nature became NATURE.

For New Hampshire, the limit of Nature was the sea — in this case, the strip of scenic sandy seacoast outwardly bounded by the stark and beautiful Isles of Shoals. Early in the nineteenth century, Thomas Cole, first of many great artists to work in New Hampshire, put Mount Chocorua in the background of his "Garden of Eden," a celebrated painting wherein small and chaste human figures hail the rising sun in a vast and awesome natural setting. Cole wrote that in the White Mountains "the savage is tempered by the magnificent" and that the wilderness is yet a "fitting place to speak of God." Such a wilderness is almost as hallowed as wild, and it does not so much howl as sing. At midcentury, it would be Thoreau who best sang that song: "I long for wildness ... woods where the wood thrush forever sings, where the hours are early morning ones, and there is dew on the

grass, and the day is forever unproven . . . a New Hampshire everlasting and unfallen."

When illustrator William Bartlett traveled from England to New Hampshire to make prints for publication in London, it was clear that something was in the air. And it wasn't just the mountains. What caught the artist's eye, and the public's too, were entire landscapes of enterprise and cultivation, farmscapes, villagescapes, the whole rich and lively Currier and Ives rural panorama. With that came a dawning awareness of something else about New Hampshire's living landscape. Maybe it hadn't been realized at the time, but in retrospect you could easily see it: New Hampshire rural architecture had reached its peak on its very first try! The rectangular meetinghouse, the two-story Colonial, and the story-and-a-half Cape Cod farmhouse were instant masterpieces of decorum and utility. They were essentially imports from Massachusetts, like most things in that day, but from colonial times until the land was well settled in the nineteenth century, every farmer worth his nails knew how to build a fine and stylized house for his family, a house such as one in which he probably had been born. Excellence came with the territory. They cut their own trees, hewed their own beams, and sawed their own boards at the neighbor's mill, unconsciously creating scenic village and farm settings to nourish the nostalgia of a later day.

By the time we were well into the nineteenth century, the implicit message was eloquent and clear. New Hampshire's original granite wilderness had been restructured as a new and living landscape. A goodly part of its new life, of course, belonged to landscapes of the imagination. Through the paintings of Cole and Church in the 1830s and 1840s, through whole schools of painters who followed them into New Hampshire and into fame, through oft-reprinted guidebooks, such as that of Starr King, through illustrators, writers, and travelers, New Hampshire scenery at its best, its rural architecture and sylvan mountains, its scenic seascapes and bucolic farmlands, all staggered cheerfully under a wondrous load of pious significance.

But, of course, *of course* — it is *human* nature we are finally dealing with here; so not all the exciting clamor added up to harmony. For instance, a hundred years ago, New Hampshire farming reached one of its frequent low points, and abandoned farms and rural depression could be spotted easily in every charming and uncharming hill town. And many a neighboring seedy mill town didn't offer much relief either. Just as harsh and vivid was the boisterous lumber era that crested in New Hampshire during the forty years following the Civil War. While colonies of artists were painting the White Mountains and making them known all along the Atlantic seaboard, while the railroads began making the countryside accessible to city dwellers as never before, while tourist hotels began to dot the valleys where mountain sublimities would conspire "to amaze, to sooth, and to enrapture" — just then (the year was 1867) the New Hampshire state government sold off the last of the northern public lands to loggers, to let them treat them as they wished. Lo! the timber men, too, were amazed and enraptured at what they saw in the mountains. And what they wished was this: to cut down all the trees as efficiently as possible and then move on to the next mountain slope to do the same. So they commenced to do that.

Of course, heavy erosion and forest fire then set in, and ravished the already-ravished hills: The northern landscape seemed under sudden sentence of death. Thoreau had not been dead forty years and it appeared that New Hampshire would very soon be thoroughly proven, short-lasting, and fallen; and the hour was not an early morning one. Alarms were sounded and spread, organizations sprang up, the public became agitated, legislation ensued. The legislation was good, and the valleys and slopes of the White Mountains came alive and turned green again. But it was a close call, and a hard and bitter lesson for us all — if we can remember it.

We've spent the last century learning how to live more gently with the landscape and how to let the landscape live.

So, natural rhythms roll across our horizons in cycles more visible today than ever before. We farm the land for a couple of generations, or centuries, we clear it and furrow it and tend it and harvest it; when our back is turned, the living land quickly reasserts itself to a version of what it was before we came. Crops sprout, grow, flower, mature, go to seed, die away. Whole farms grow, flourish, go to seed, die away. Villages too. One day the dam washes out, abandoned roadways revert to abutters, boundaries fade into the forest, then frost heaves topple stone walls and old millponds drain away to grassy brooks. It happens all the time, and it started happening a hundred and fifty years ago in the hill towns of southern New Hampshire. Today and tomorrow, we can see this history transpire before our eyes in parts of northern New Hampshire: Cultivated fields become hayfields . . . which lapse to pastures . . . which are abandoned to brush . . . which turn to forests. The lament for aban-doned farmlands is an old, old song: It goes back to the Roman poets and it seems never to be out of date.

Sometimes the crumbling factory beside the milldam is shored up and recycled to become, perhaps, an electronics firm. New life on an old landscape. In the southern part of New Hampshire today, many a grown-up pasture is being cut down, brushy fields are mowed, woodlots are cleared, then stakes are planted and developments grow. Elsewhere, the long-suffering sand dune is pushed into the estuary. We have learned that suburbia is as implacable as the forest. Yet pastoral dreams still inhabit our collective imaginings: We try to think it is still a rural state. And of course it is. Just look at the pastoral vistas, look at the warm, silent panoramic backdrop for fly fishermen on the First Connecticut Lake; look at those old and comfortable, winding, two-track wagon lanes that scale our hillsides; look at our sparkling granite-pebbled streambeds. And of course it isn't. Look at that stunning, mile-long scenic brick clutter of old Amoskeag buildings that leans over the eastern shore of the Merrimack River in Manchester; look at the splendid winter combination of shanty and Colonial architecture on the Squamscott River in Exeter. Everywhere we hear the dialogue of manscape and landscape. But the unambiguously good news is already in hand: The scenes in this book are quietly at work distilling all that mixed material into poetry.

So this book joins a long, long tradition. For a hundred and eighty years, the public has been presented with images of the New Hampshire landscape, beginning in 1816 with highly artificial sketches of the White Mountains on Carrigan's map of the state. And this book is a record of some of what has happened to the land-

scape since then — a partial record, highly skilled in its making, and highly selective. Why selective? Simply because we are not cynics: We all really prefer to see ourselves and where we are and what we do in the best light possible. That best light shines on these pages with a panoramic glow — photographs that began with an inspired glance and then matured to art.

When we look at these scenes, we are likely to be both dazzled and puzzled. Puzzled: Why are they so arresting? The first and banal response is that we don't commonly see panoramic photographs, and almost never a book full of them. This is not the shape that frames what we see when we look out a window, not the shape of the paintings on our walls, not the shape of a normal book, nor even of a column of type. Indoor conventions, all of them; yet so strong are they that we do an involuntary double-take: Our eyes struggle with the novel format even as they are dazzled by the rich sweep of details. The wide angle may collapse the sky or drag us across the horizon; it pulls us to the edges of the frame and alerts us as never before to the long curves and contours of our landscape. Add to these dynamics the arts and wiles of unusually skilled photography, and we know something is at work to lure us to *come inside* these photographs.

Come inside, then, and realize that most of these panoramic scenes are the end product of a long process. Oh, not the *photographic* process — that took for each of them only twenty or thirty false starts, plus a few days to find the right spot, then three or six returns to the same place, and maybe a few hours waiting to get the light right, plus time to process and print, and time to discard and finally select. But Peter Randall does that all

the time, and has for years, calling it work. No; it is the *scene* itself that took whole lifetimes to reach the point where it could be snapped in a micro-second. Where our forefathers read howling wilderness into what they saw, we find the imprint of time and history in what we see. Glance around the Granite State, and everywhere we see scenes we can look *into*, portraits with all the depth of history and the centuries-old struggle of man and nature. We have but to focus our mind where our eye is.

For example, this book's jacket photograph — classic New Hampshire — encapsulates all the history that has transpired on that spot and, by intimation, in New Hampshire. How do we love it? Let us count the ways: A virgin wilderness thrived there three hundred years ago; an Abenaki family walked through it and left a name, Chocorua, now affixed to the distant mountain that is just out of sight behind the tree; a pioneer cleared it, possibly sending its pines to England as masts for the king's navy; then his neighbor helped him build a granite stone wall so they could keep the sheep in the meadow and the cows from the Indian corn; the wall, ending so abruptly now, was once continued by a brush fence (we presume), which fell and slowly declined to compost and rotted to soil a hundred years ago; the predatory forest then crept back, and for generations there were pitched battles to keep the fields clear, a battle lost on yonder side of the wall (oh, bad for farming, great for viewing). For years and years, crops and forest faced off across that wall. Just now the scene is becalmed, but still deep, still heavy with memory, still imprinted faintly by every wave of human and natural force that has swept across it since its granite origins, and we still contrive to draw its story from the scenic fragments that remain.

Each of these photographs is powerful enough to stand alone. Some viewers may, however, find themselves drawn to the paradigms that underlie so many of them — Nature and Culture, Rural and Urban, Myth and Reality, Matter and Spirit. These are the great imponderables, as ageless and inexhaustible as the sea. You cannot photograph *them*, but you can catch their effects, their echoes, and the shadows of their charms, as Peter Randall does; for here, side by side, are God's own craggy cliffs *and* our humble stone walls, white mountaintops *and* white steeples, manmade millponds *and* virgin mountain waters.

Everywhere, the artifacts of human life intrude upon the handiwork of God. Some purists affect to view the human imprint as a defilement, which it sometimes is; but to suppose it always is, is a boring sentimentalism. There is a less combative way to see the drama: simply in terms of the inevitable interplay of nature and culture, and the recognition that some places mysteriously acquire dignity by human association. Ah, yes, we want to say, but then let the scale be appropriate to the logic and the power of the landscape. And, indeed, in these photographs the people have all politely withdrawn beyond the sidelines. There are no personalities, stars, or celebrities; nothing is gaudy or self-important. There is no typical New Hampshireman, a citizen we don't know anyway. Eloquent in their tranquillity, many of the photographs whisper quietly, ". . . and there's nobody else here!" The eye of the soul craves vacation from importance and bustle and business. Here are scenes to be inhaled.

Washington, New Hampshire
June 4, 1996

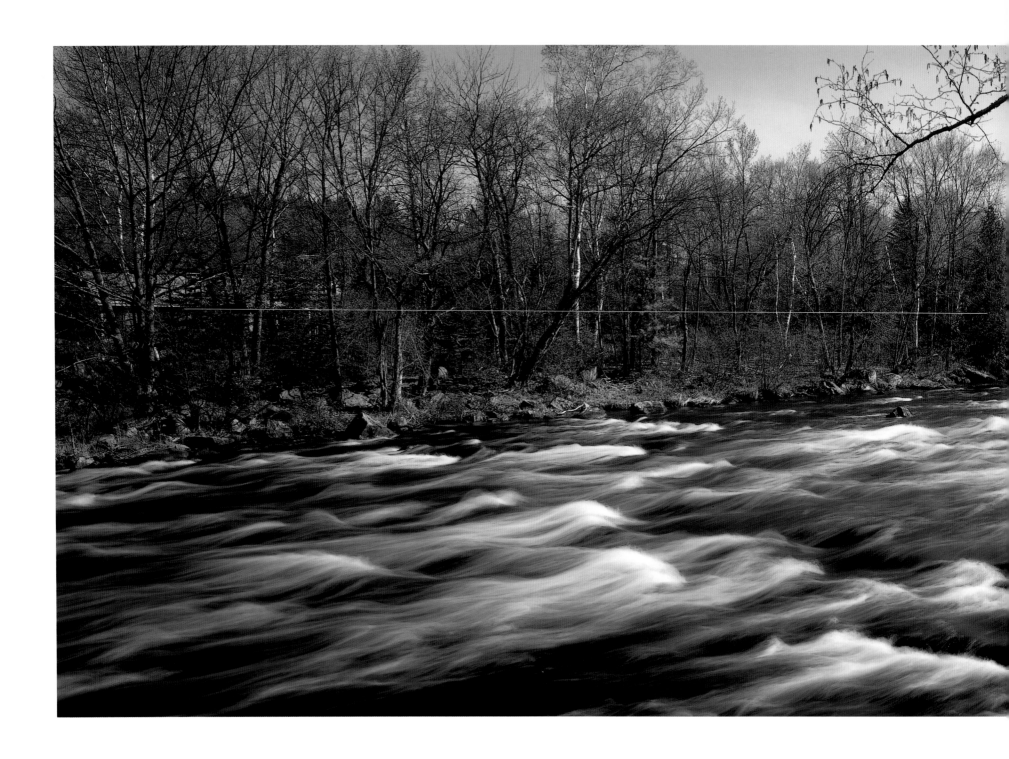

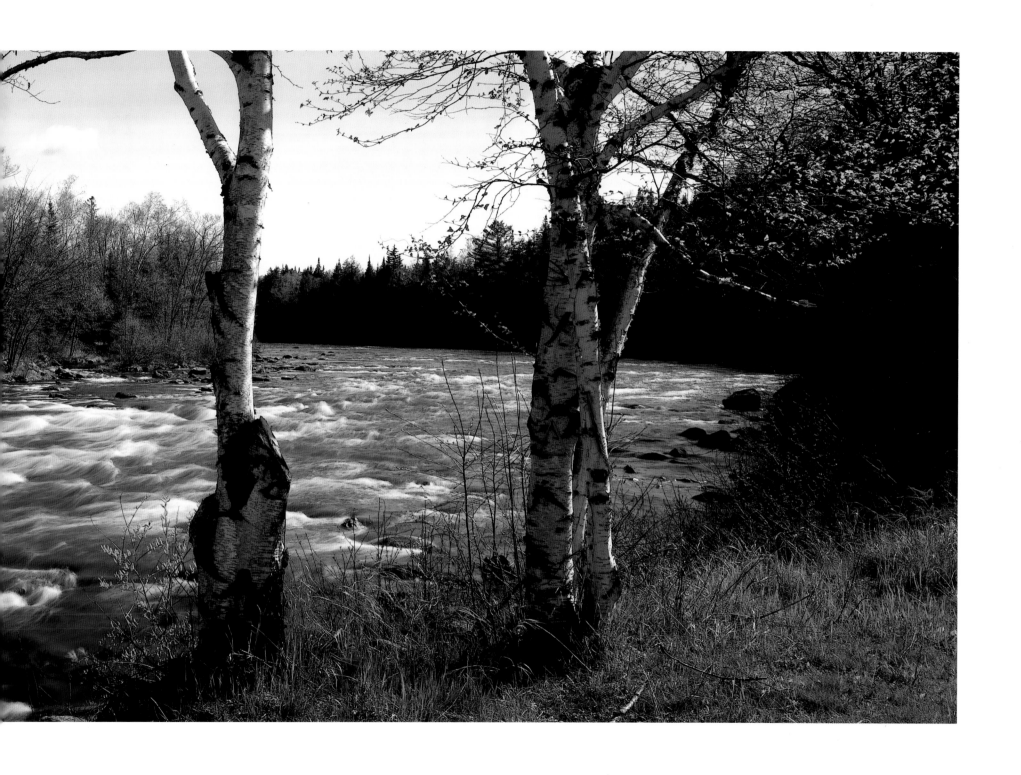

Androscoggin River, Errol

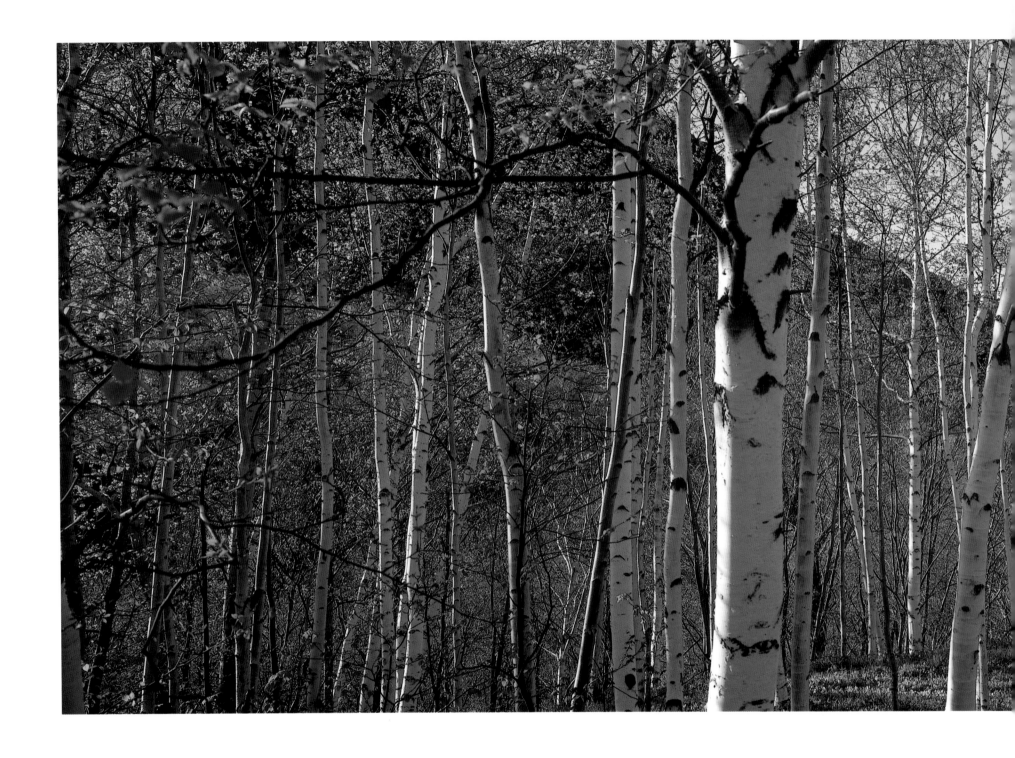

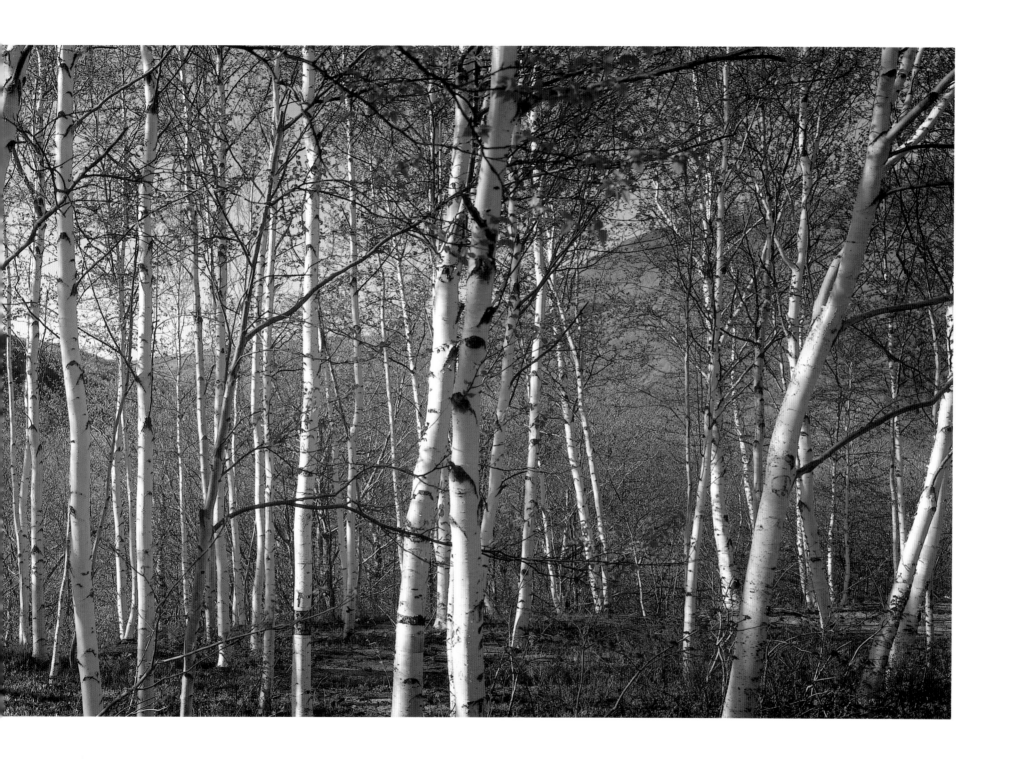

Birches, Pinkham Notch

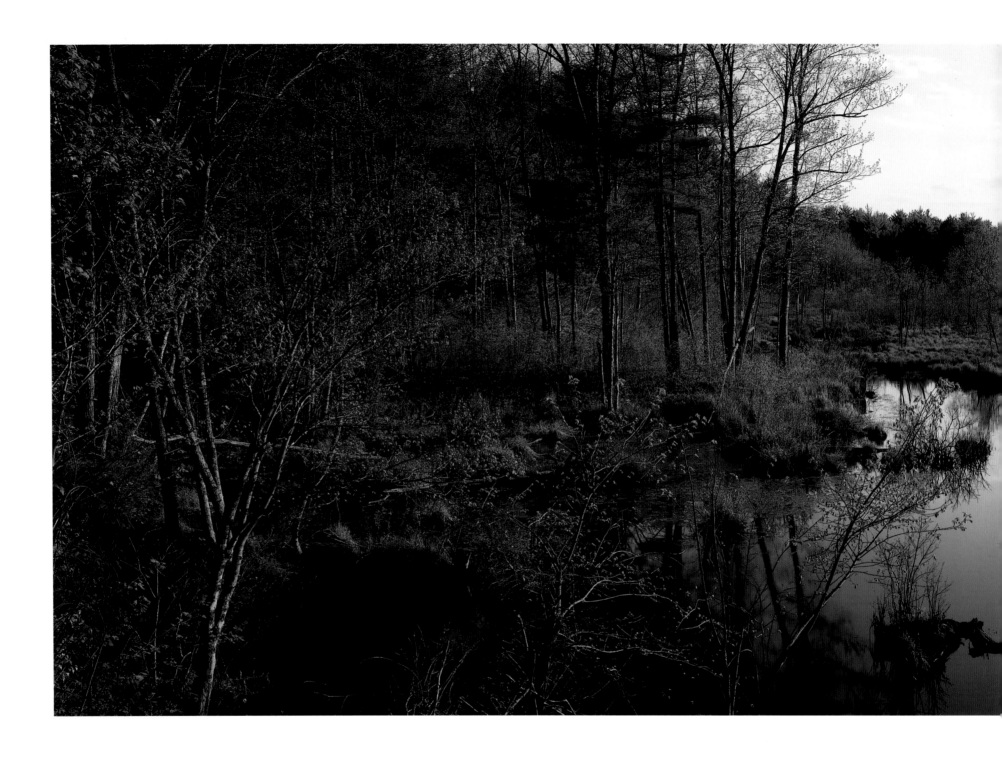

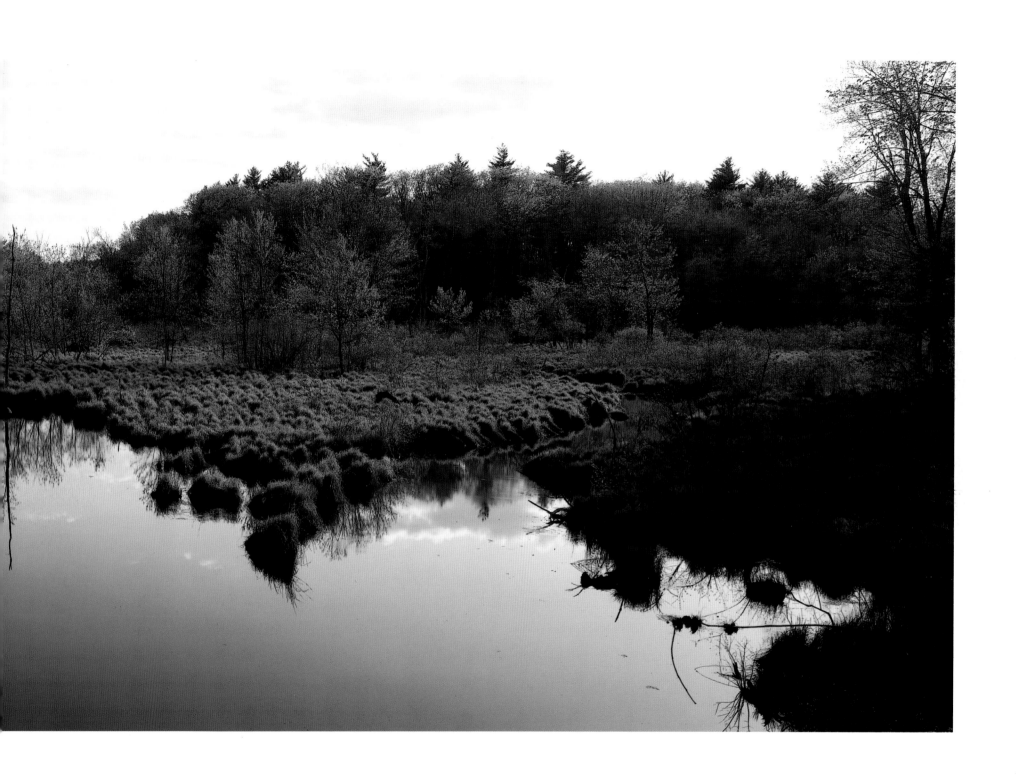

Spring afternoon, Brentwood

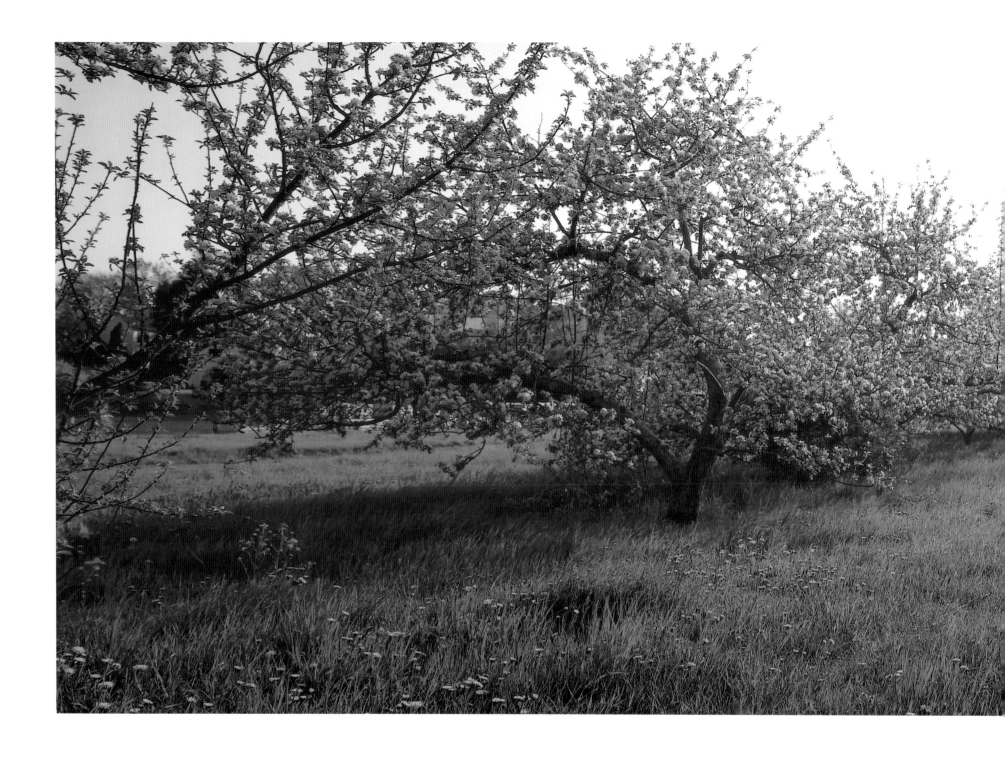

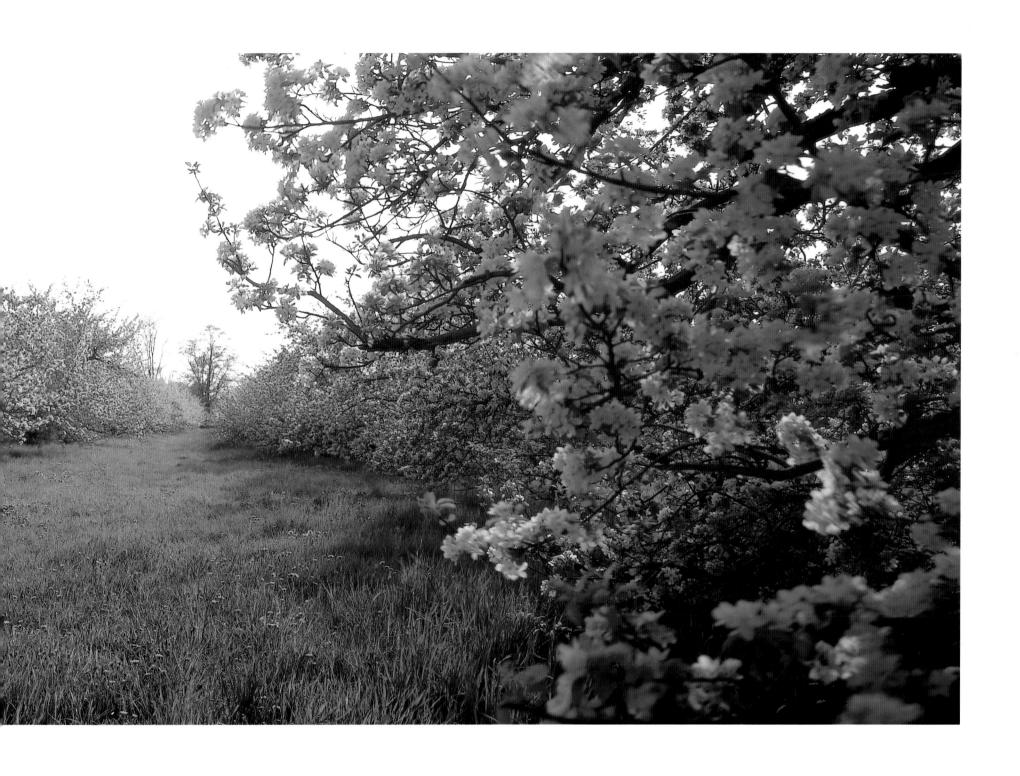

Apple blossoms, Hampton Falls

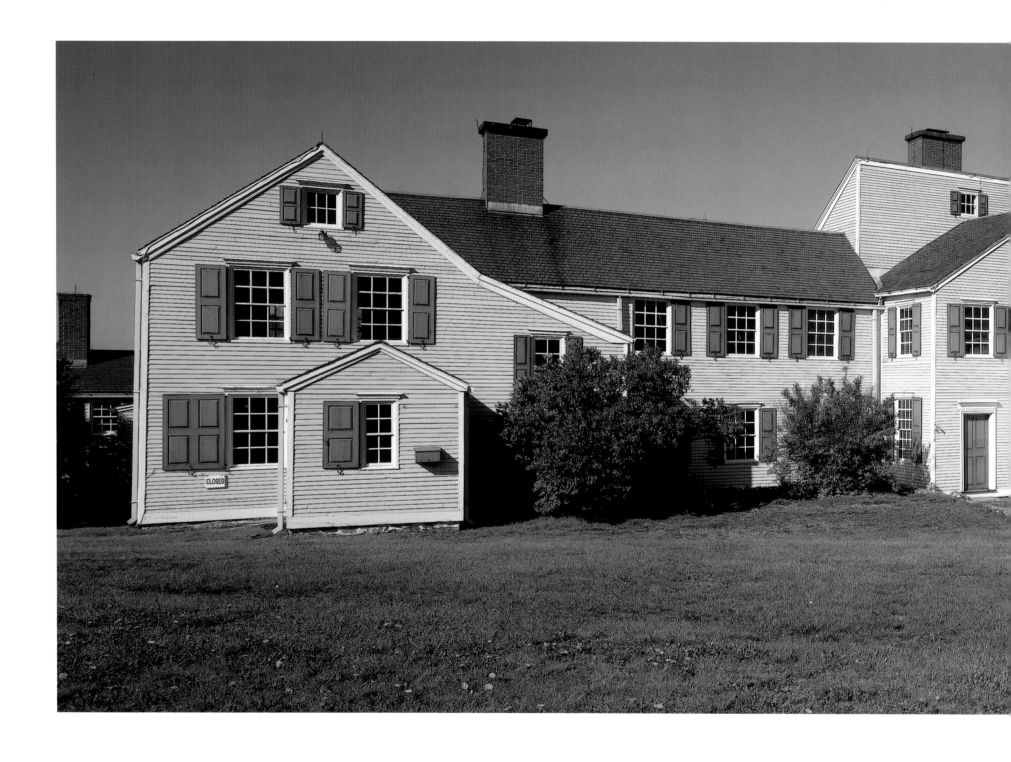

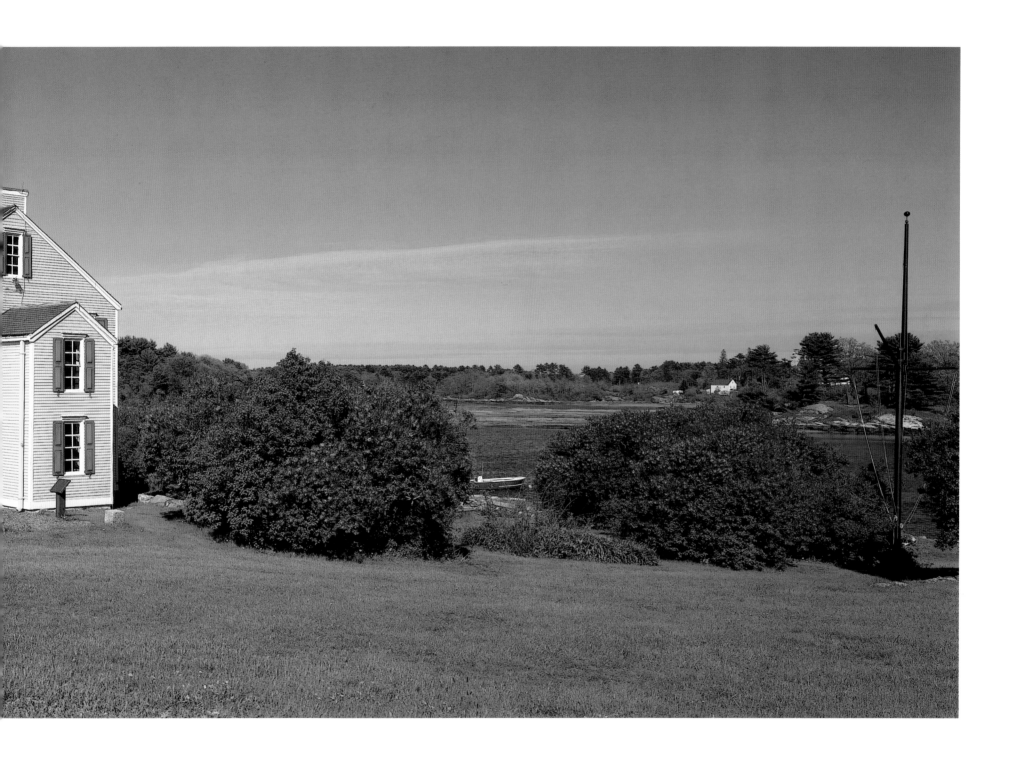

America's oldest lilacs, Wentworth-Coolidge Mansion, Little Harbor, Portsmouth

Robert Frost Farm, Derry

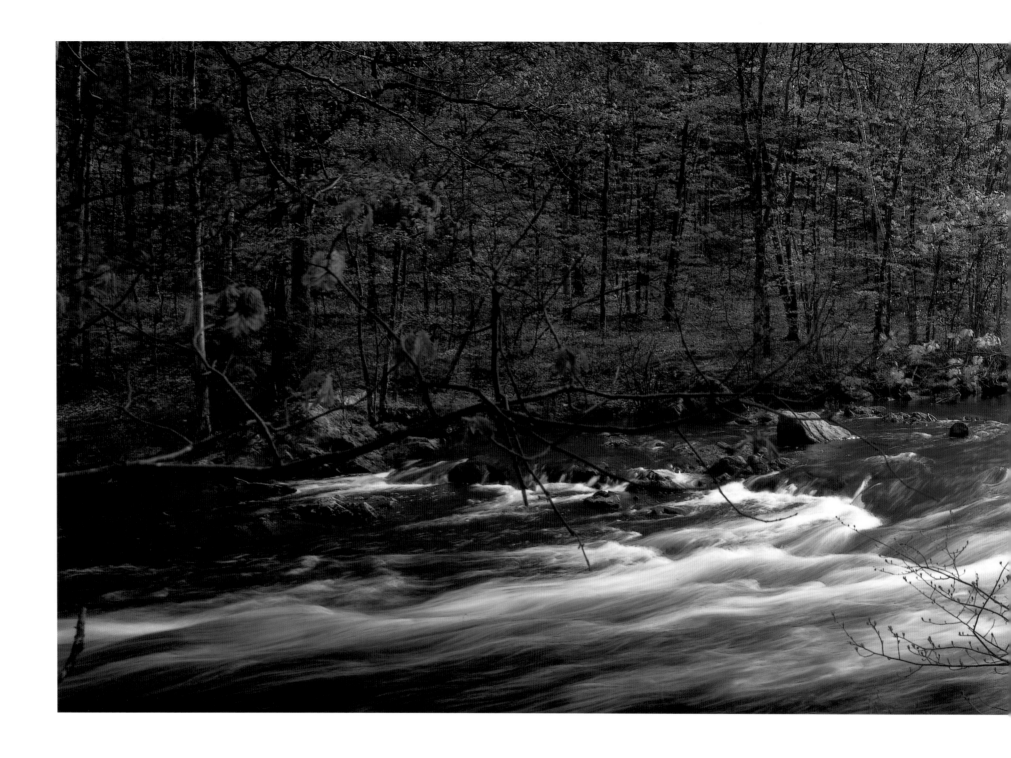

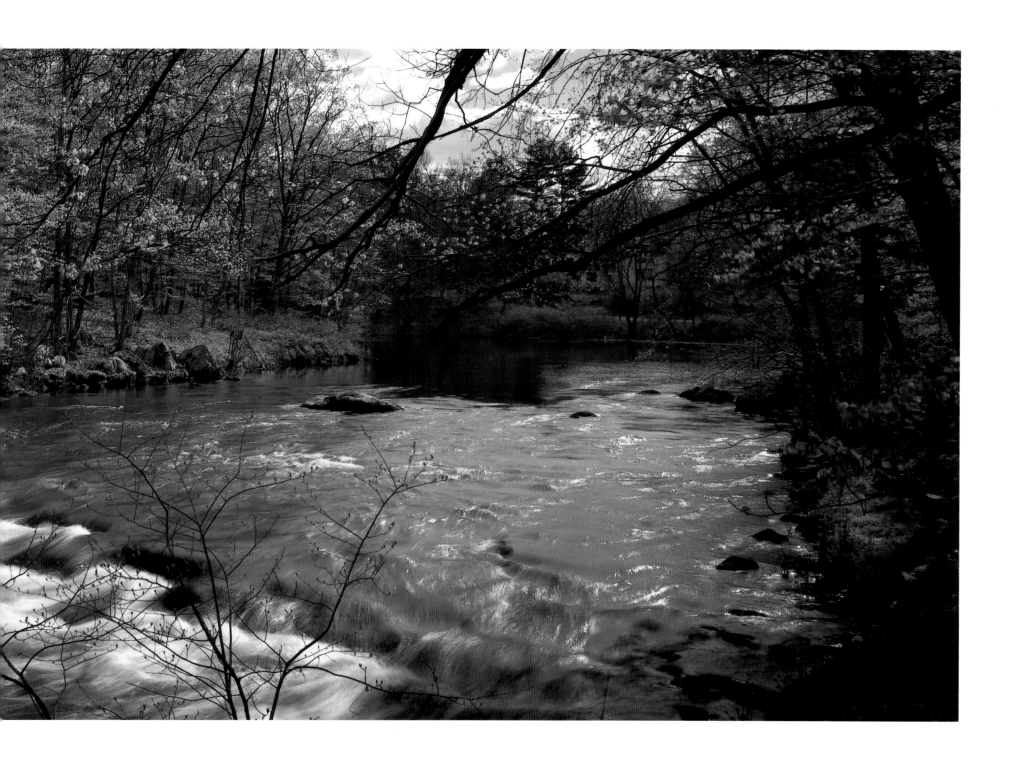

Lamprey River, Durham

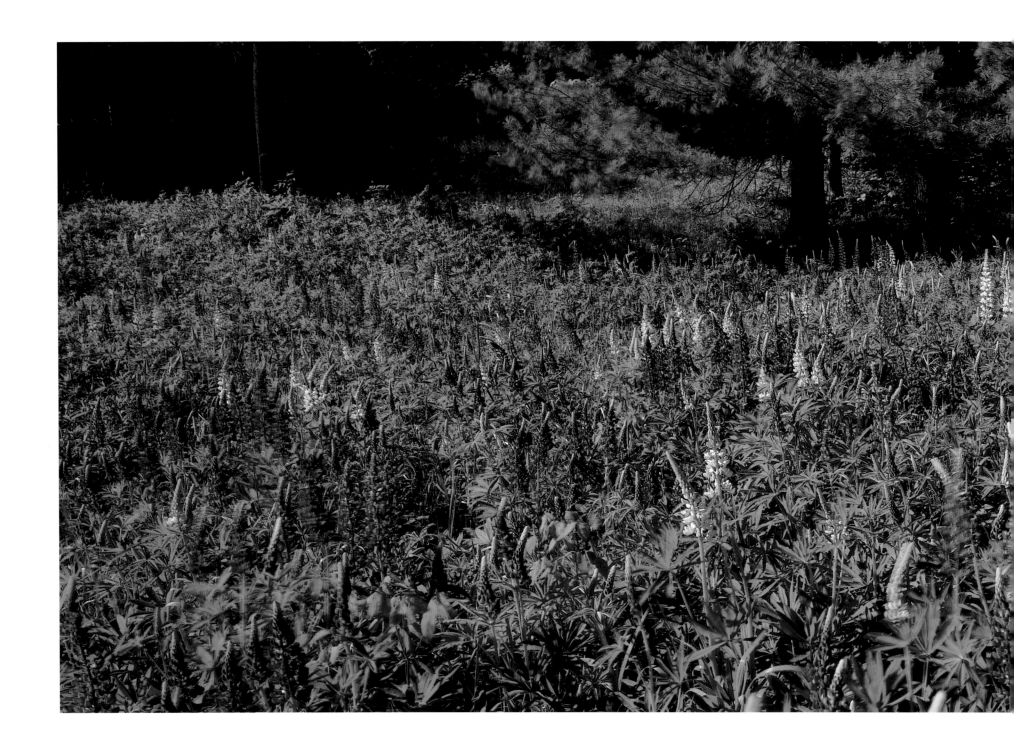

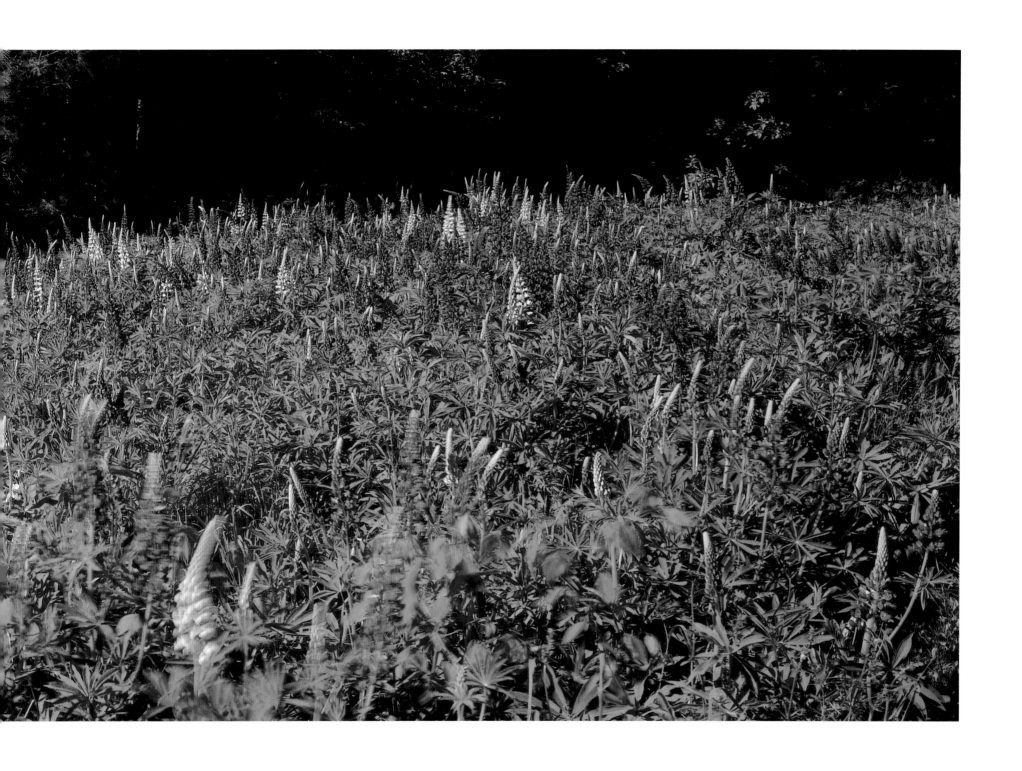

Lupine meadow, Jefferson

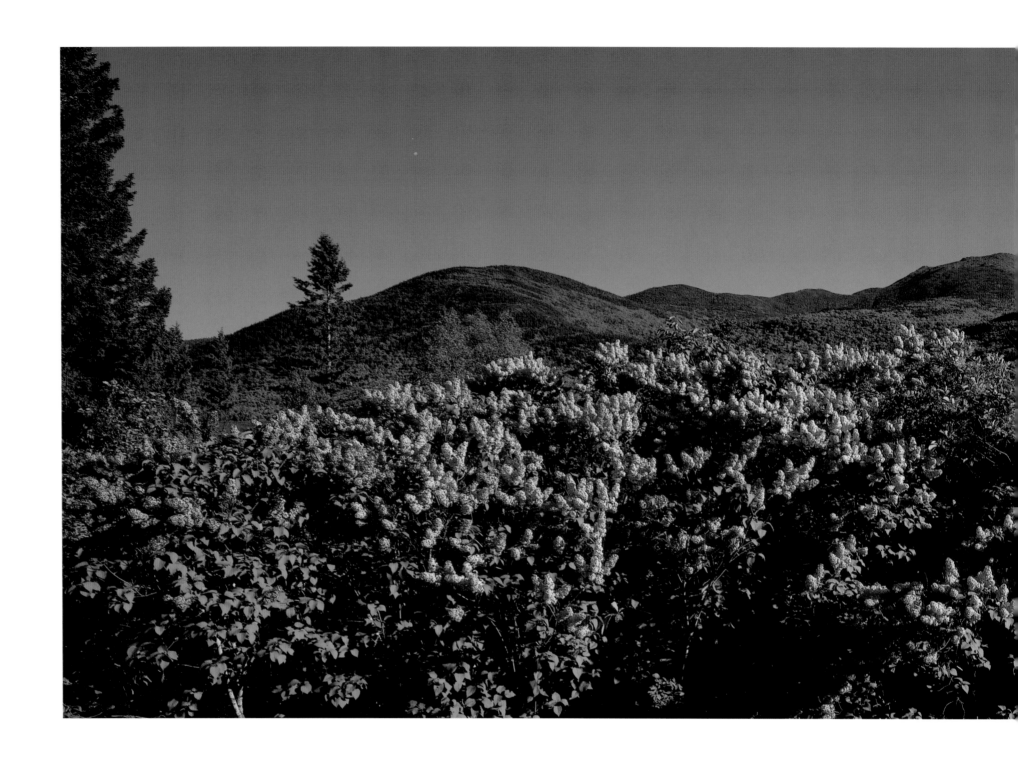

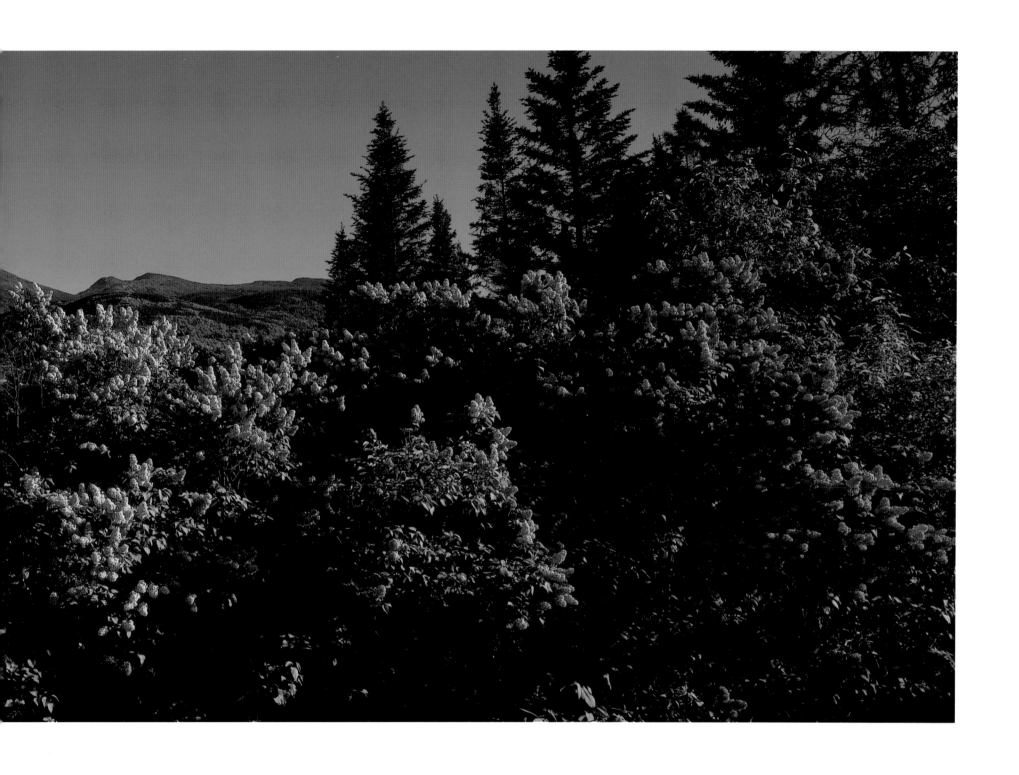

Lilacs and Mt. Madison, Randolph

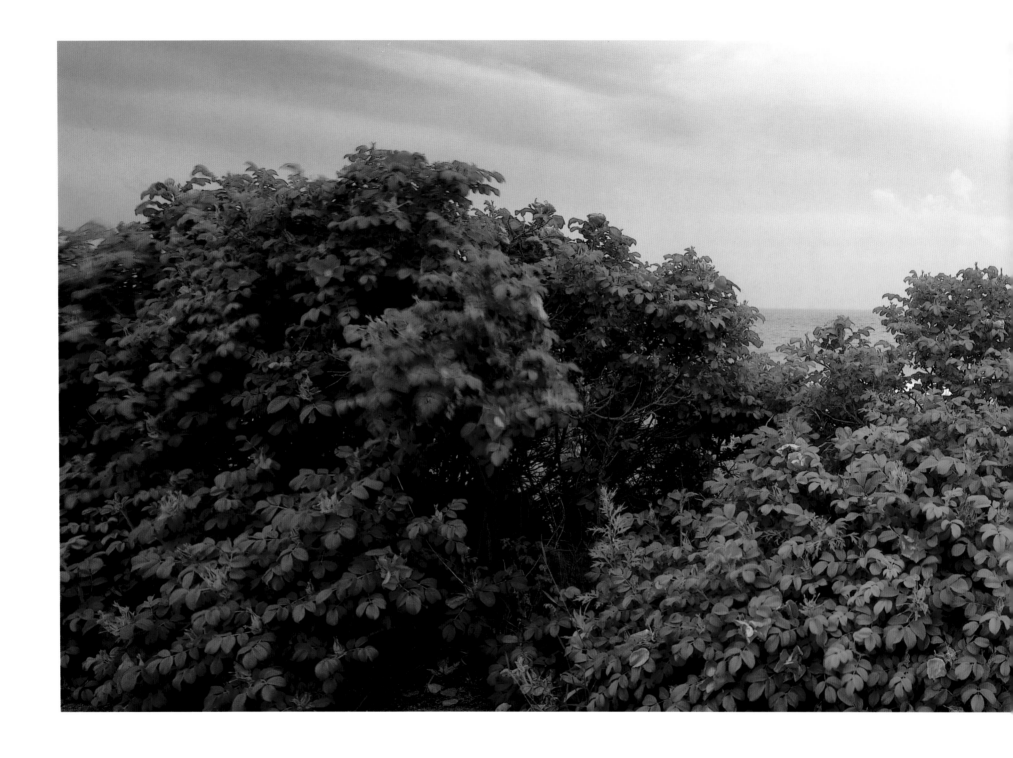

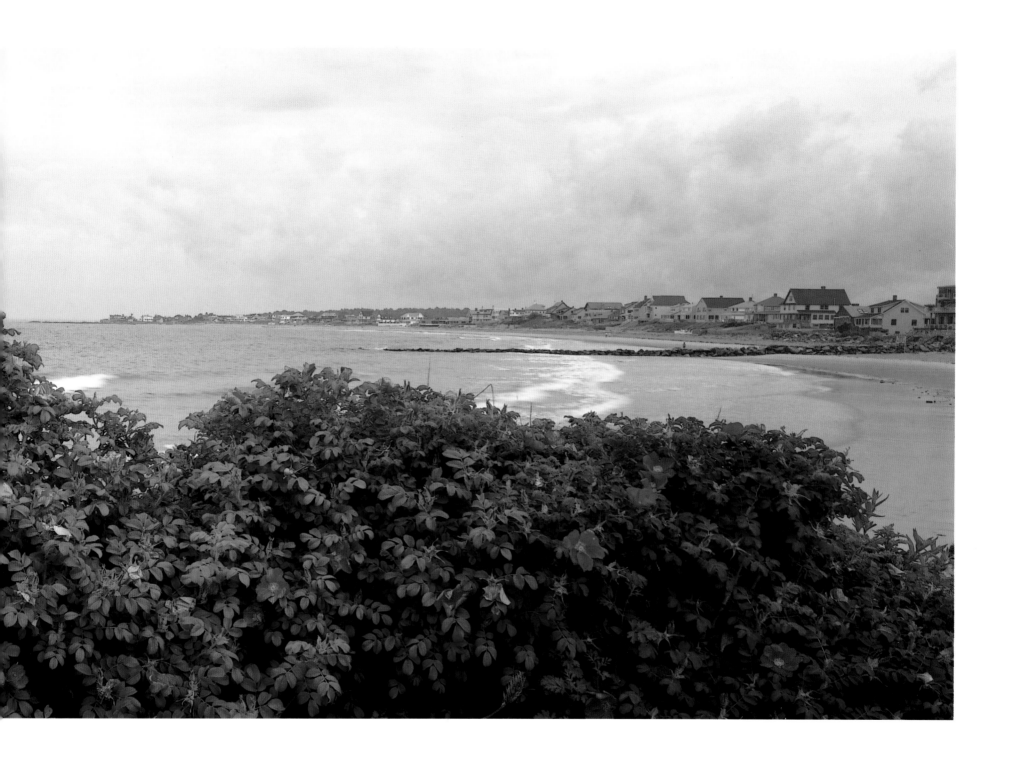

Rosa Rugosa, Wallis Sands, Rye

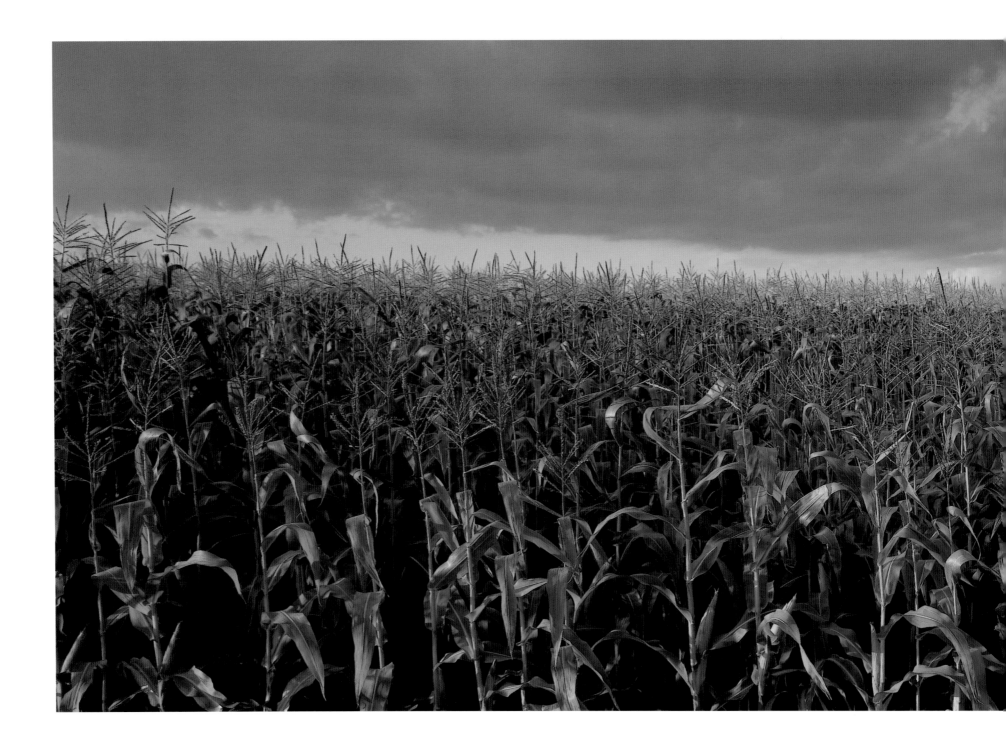

Cornfield, Northwood

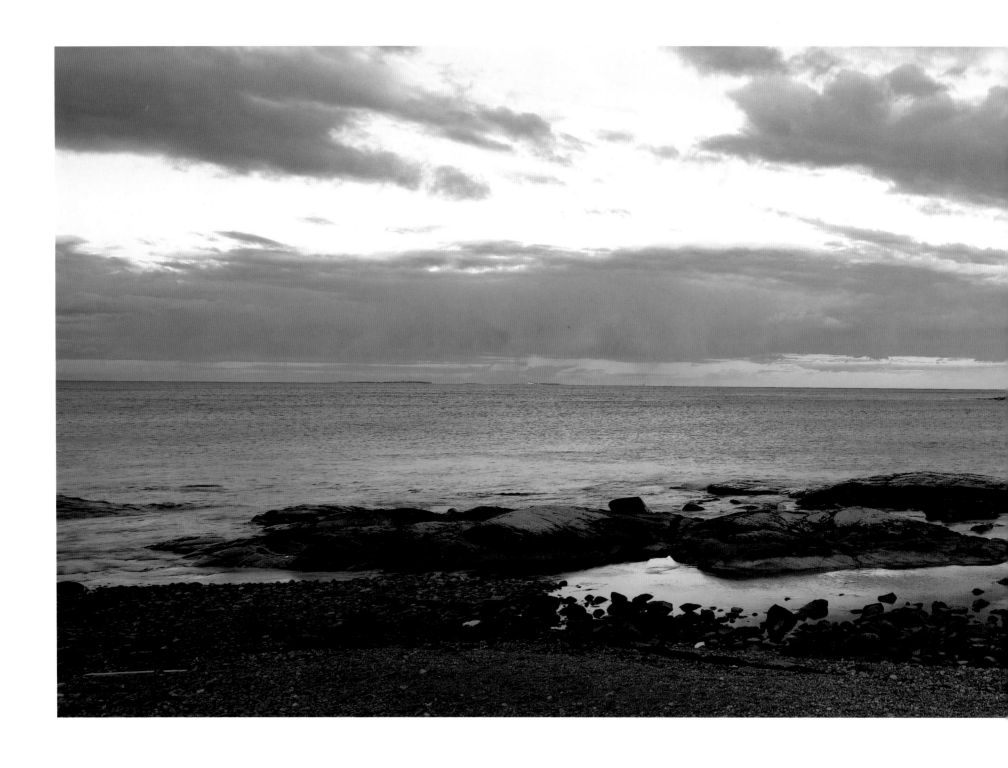

Sunset light and Isles of Shoals, from Rye

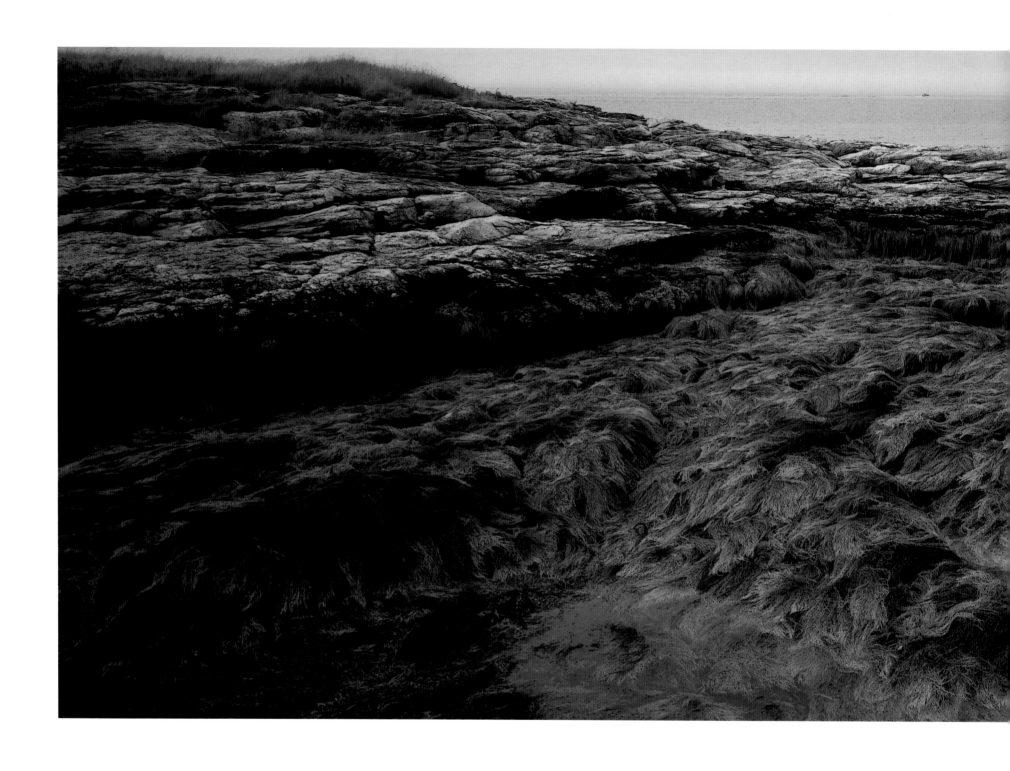

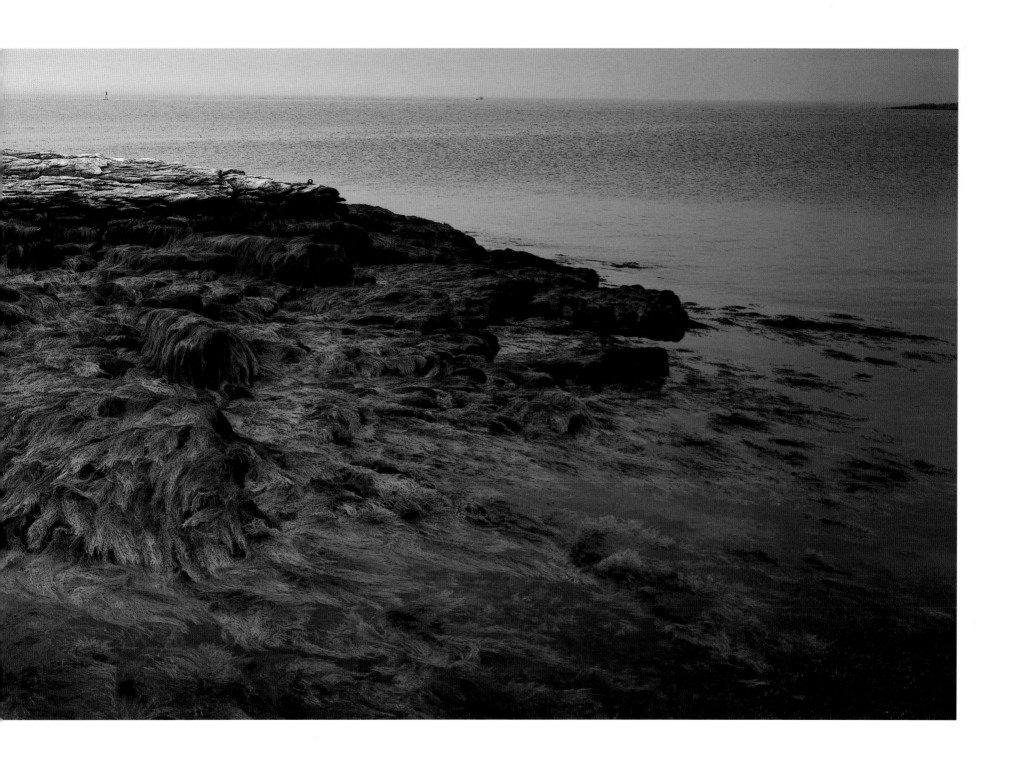

Rockweed, Star Island, Isles of Shoals

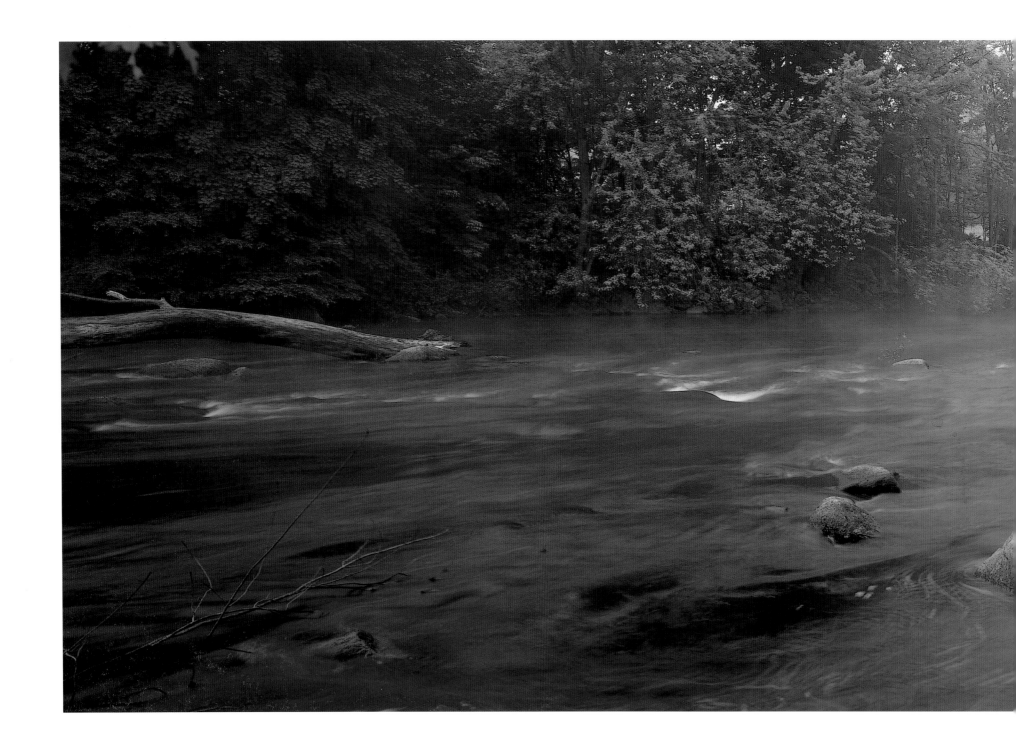

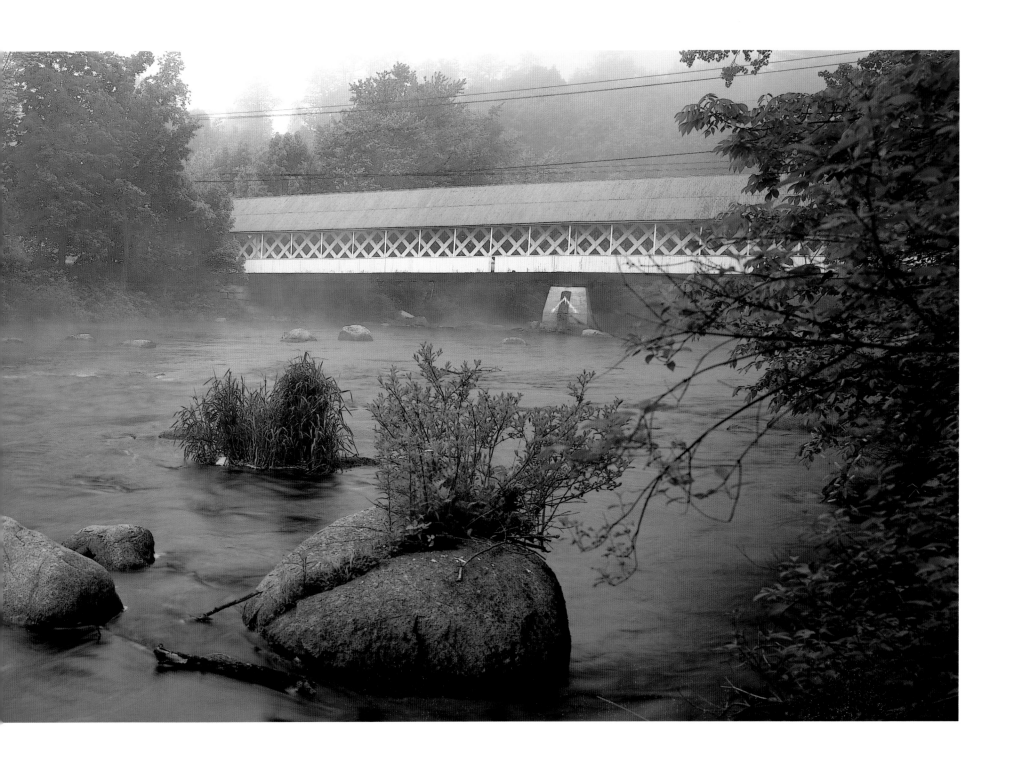

Winchester-Ashuelot covered bridge, Ashuelot River

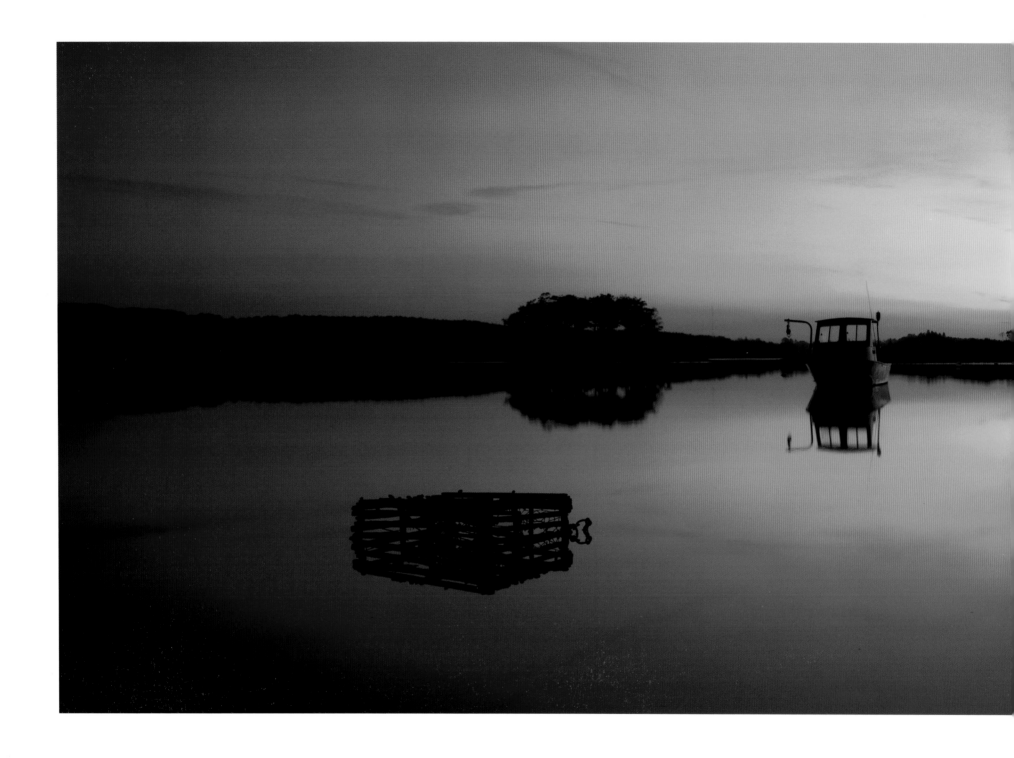

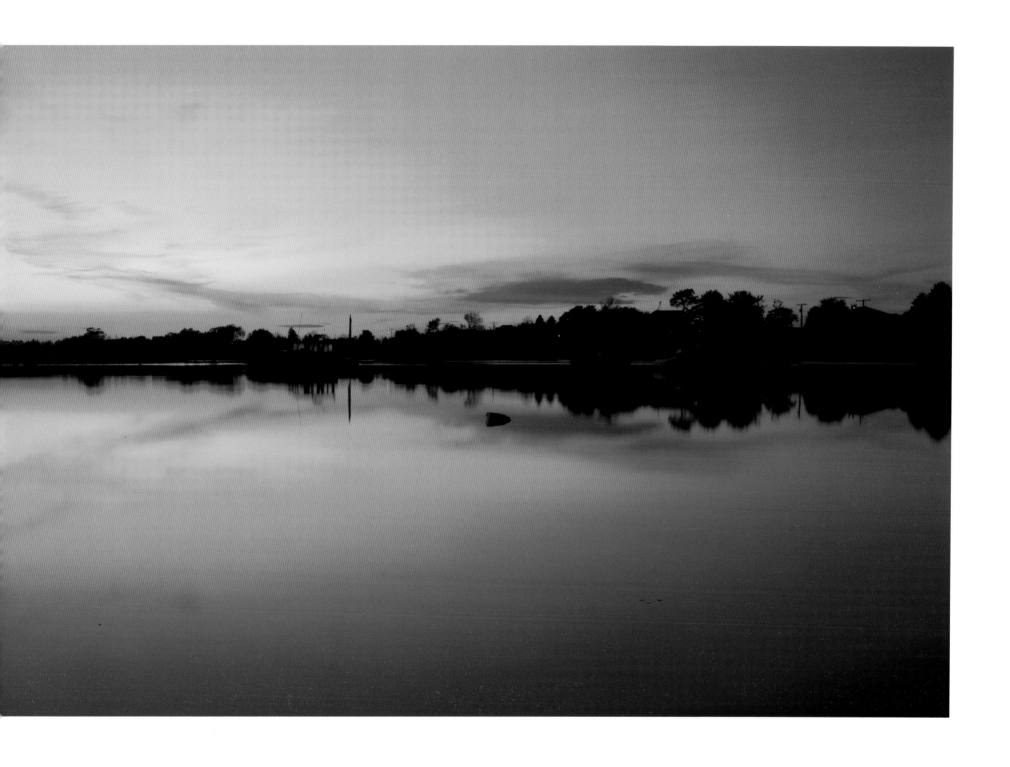

Sunset, Back Channel, New Castle

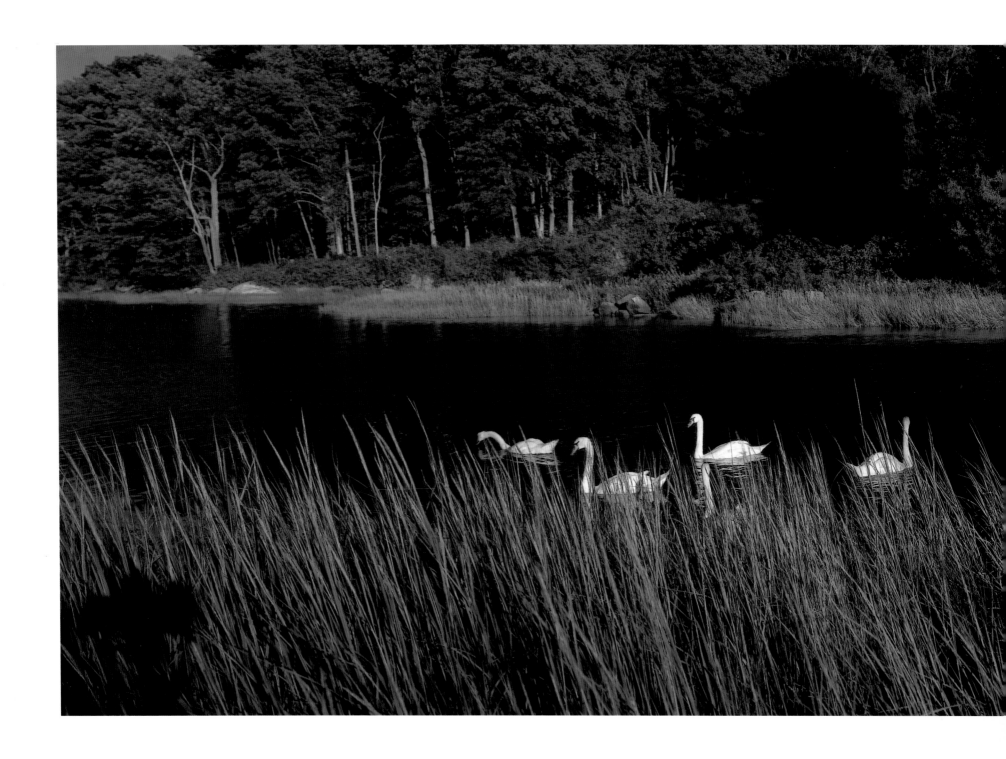

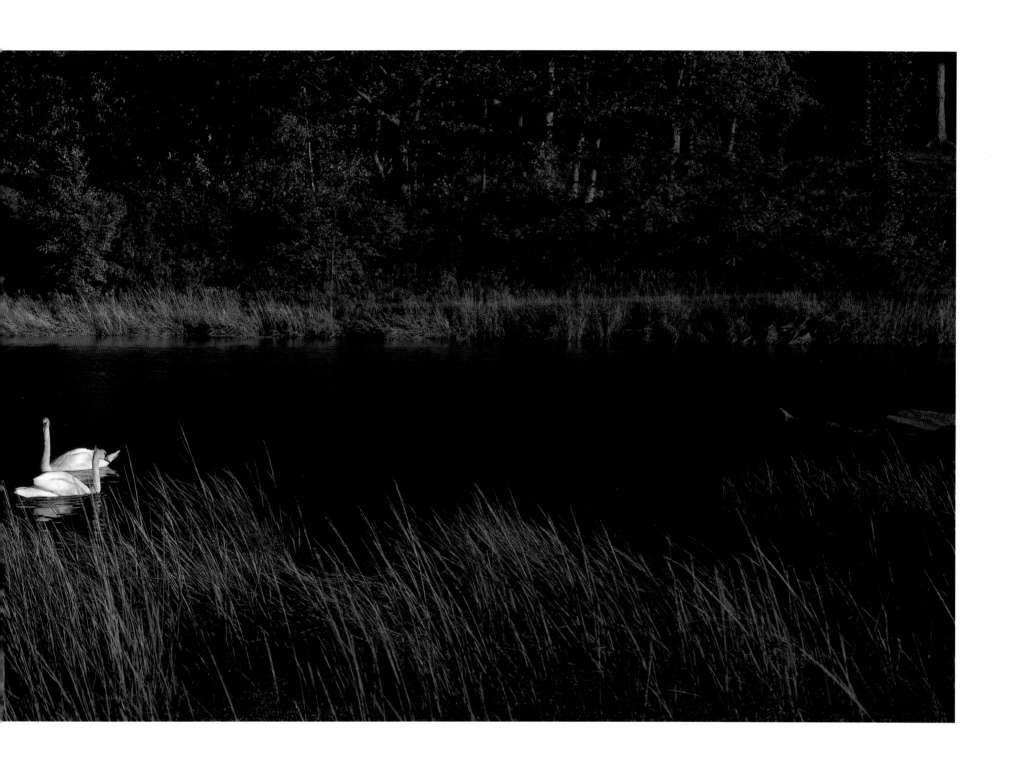

Wild swans, Oyster River, Durham Landing

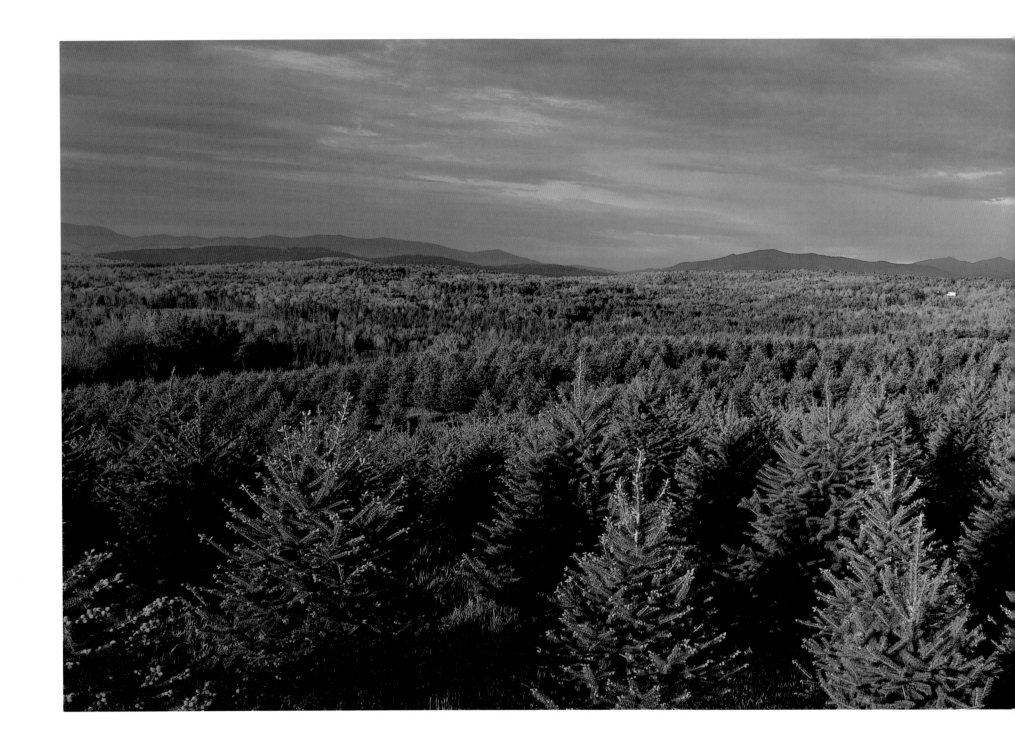

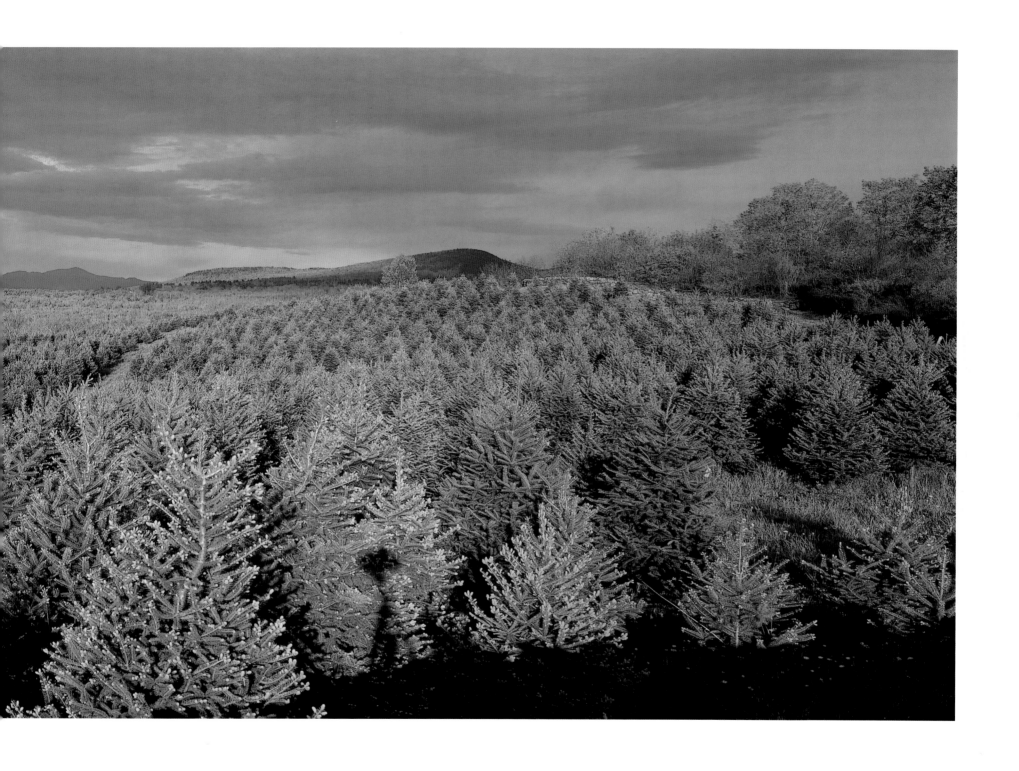

Christmas trees and the Presidential Range, from The Rocks, Bethlehem

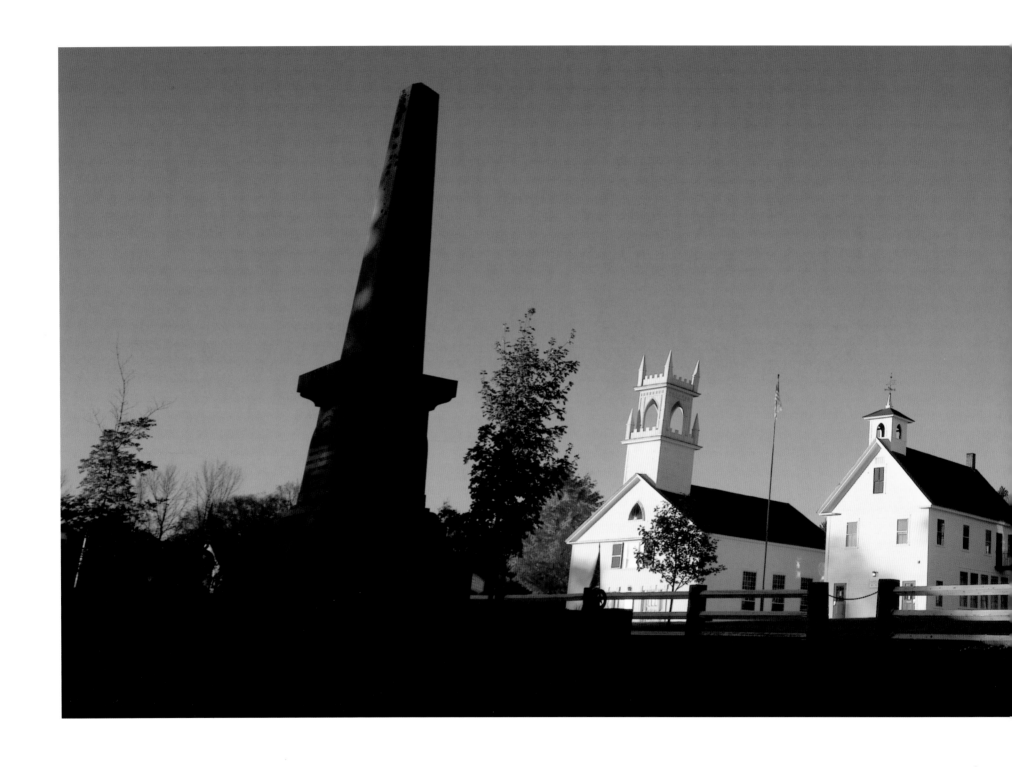

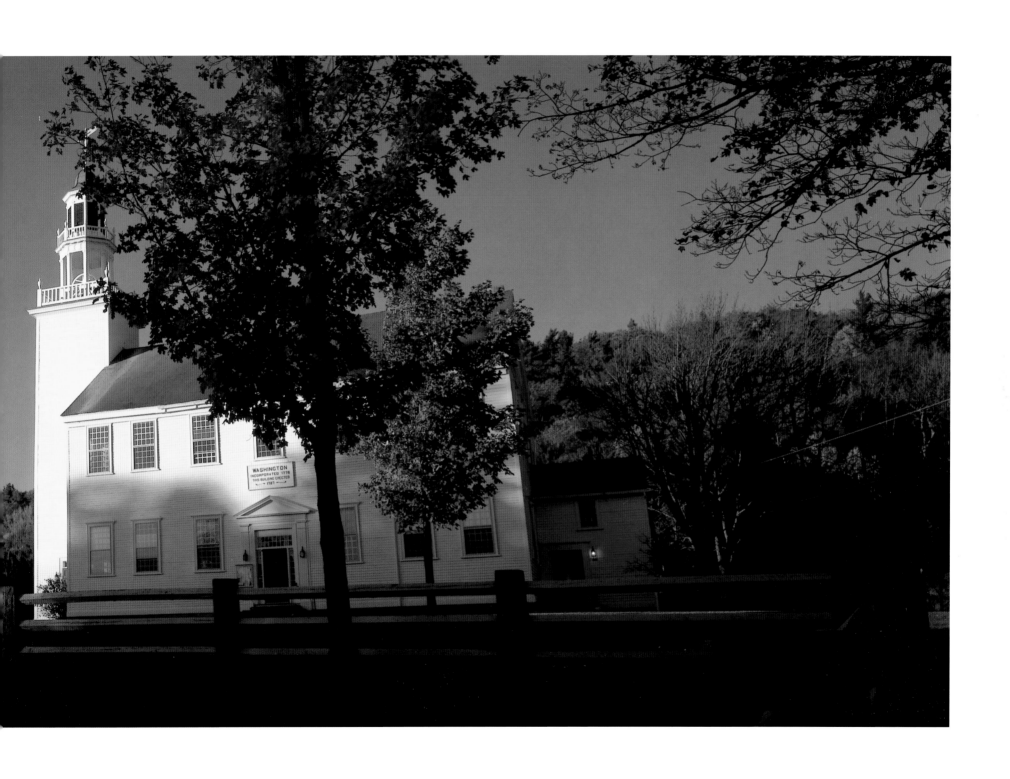

Village center, Washington

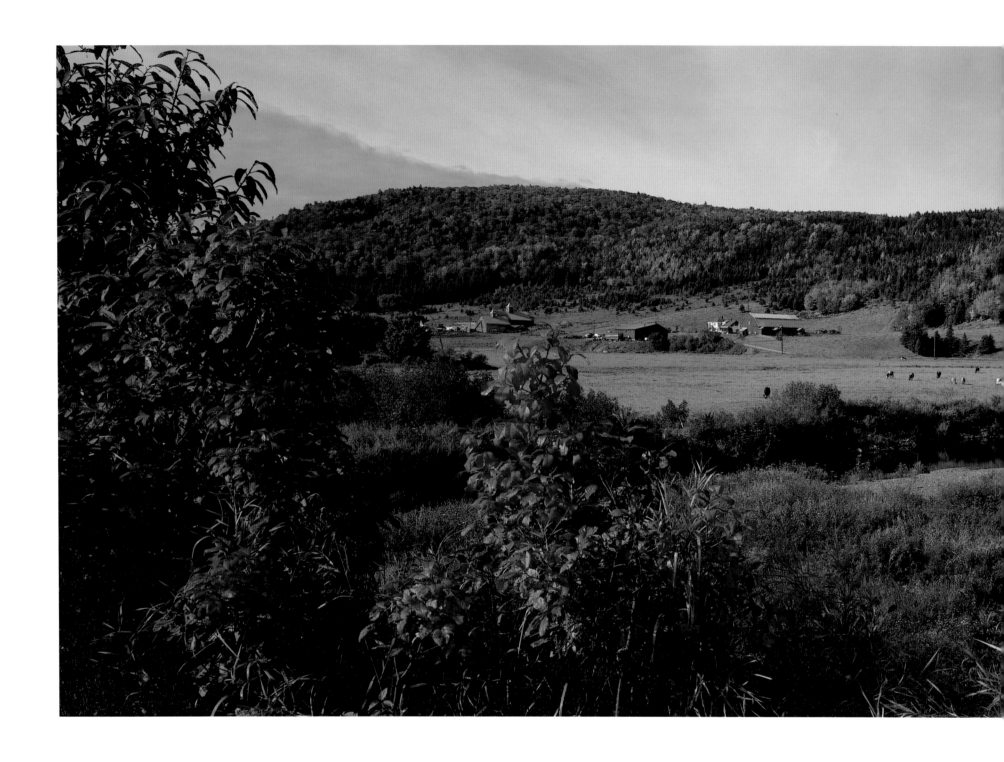

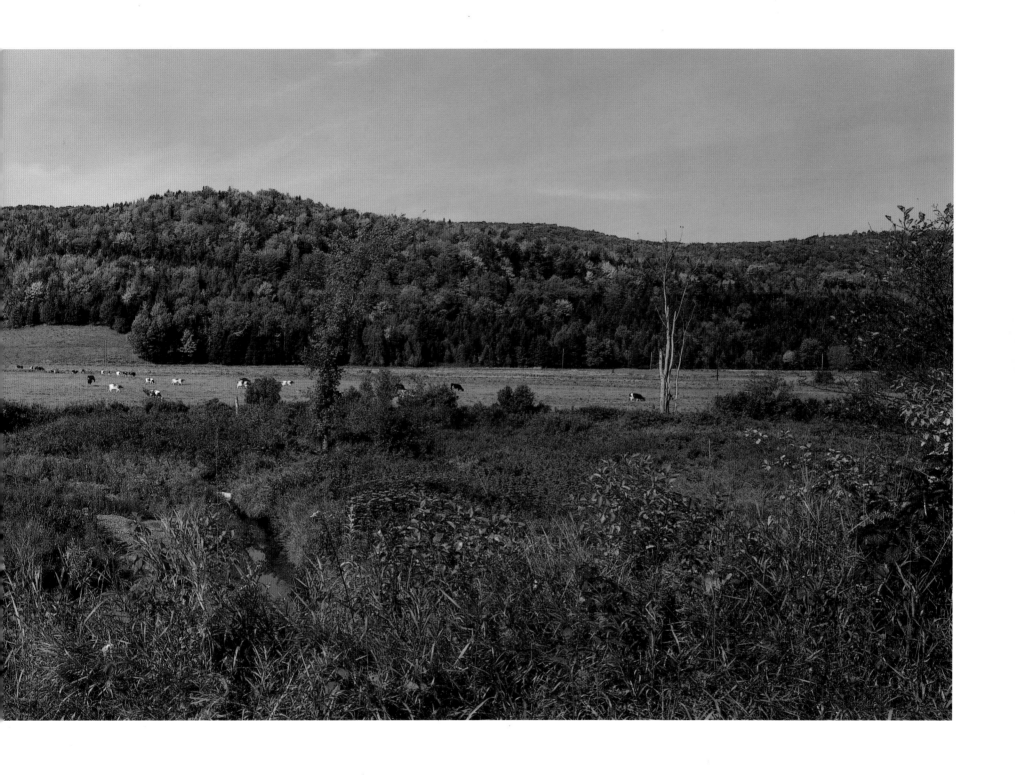

Dairy Farms, Indian Stream, Pittsburg

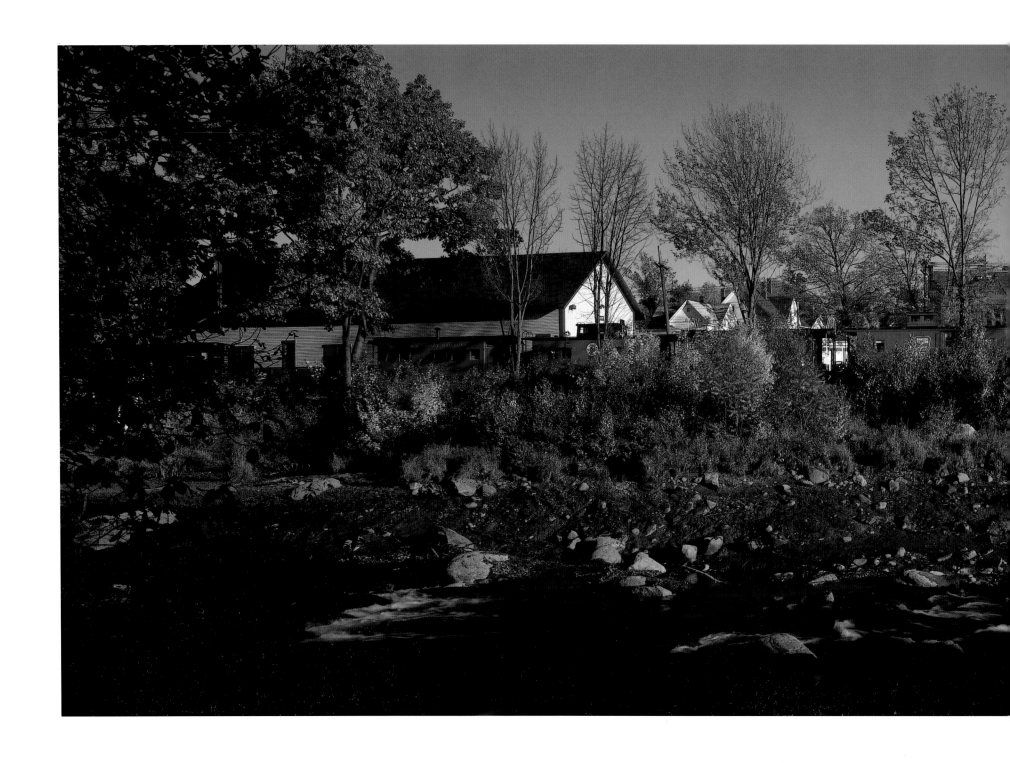

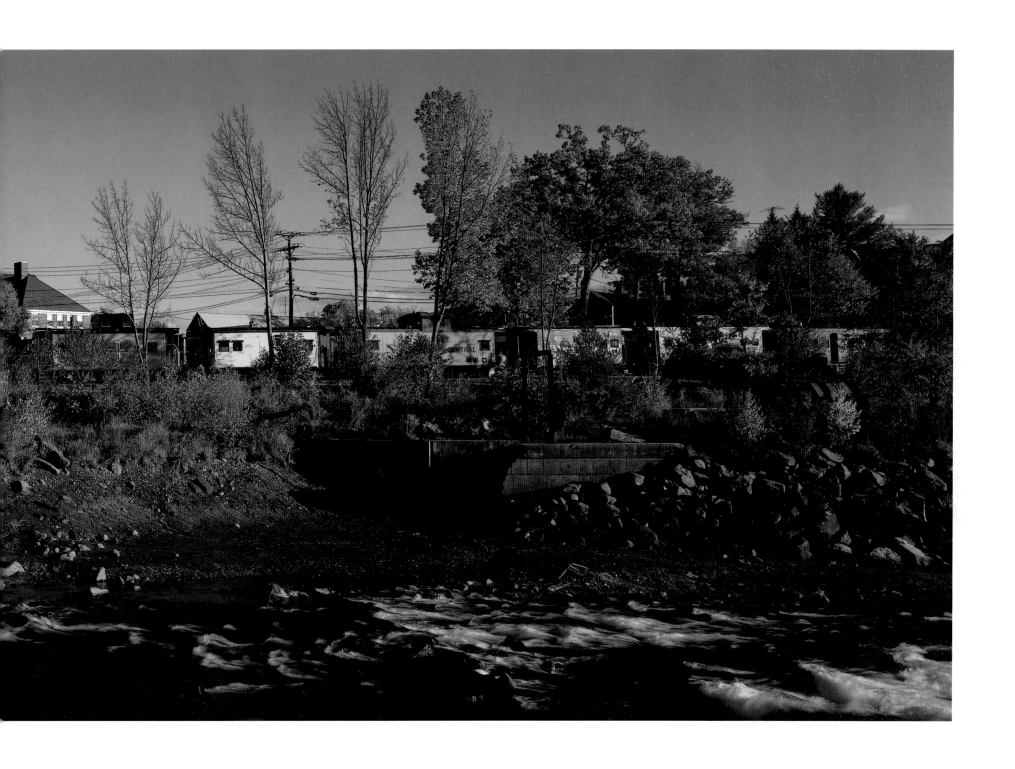

Merrimack Valley Railroad, Winnipesaukee River, Northfield

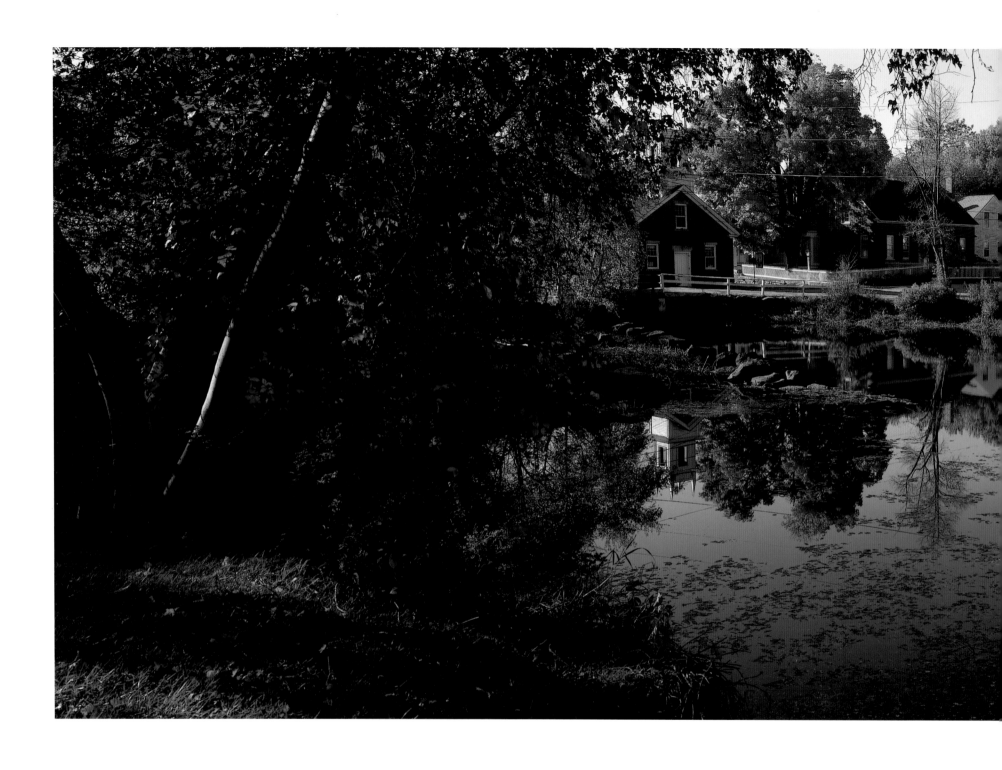

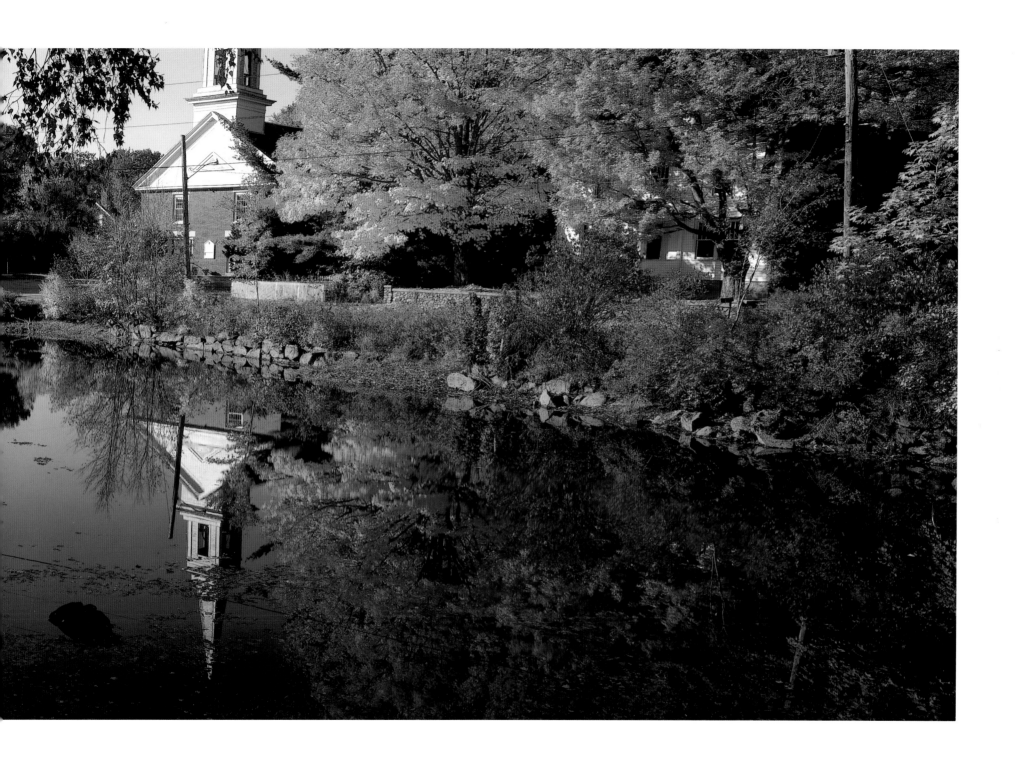

Mill pond, Harrisville

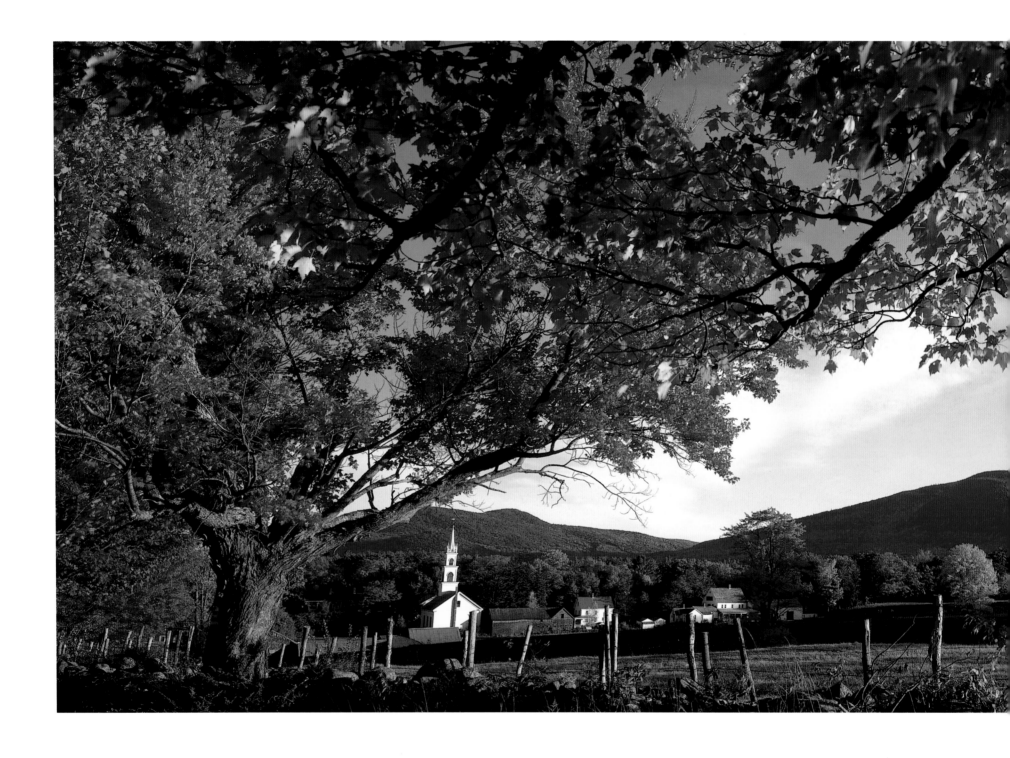

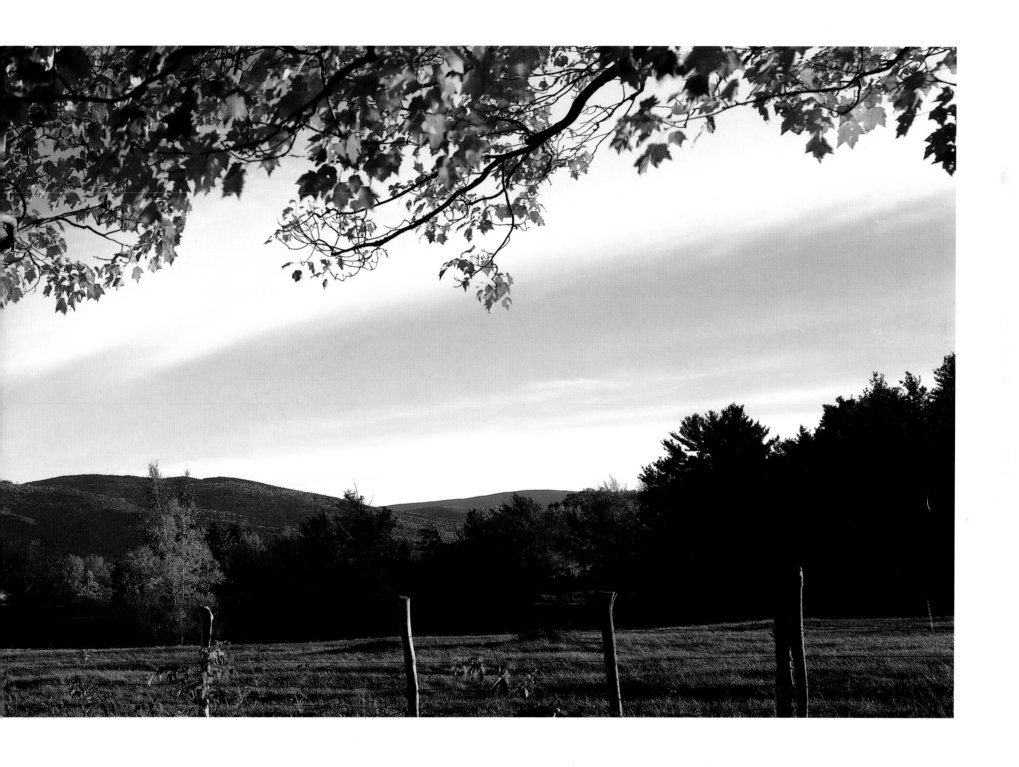

Tamworth

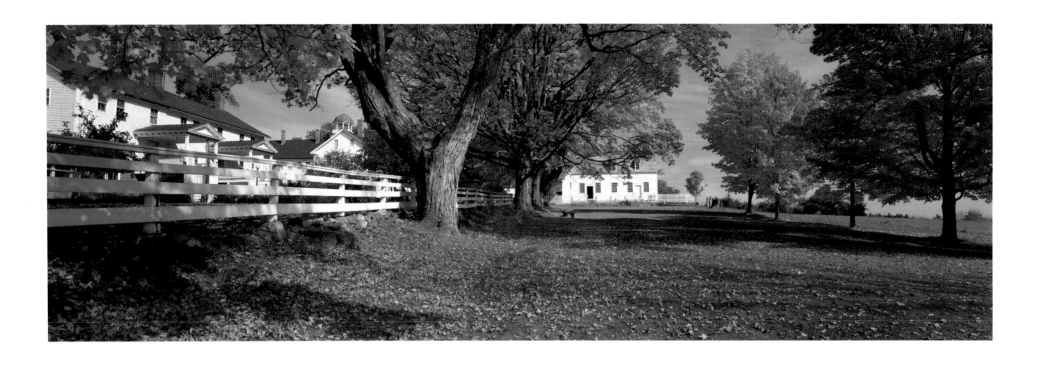

Canterbury Shaker Village

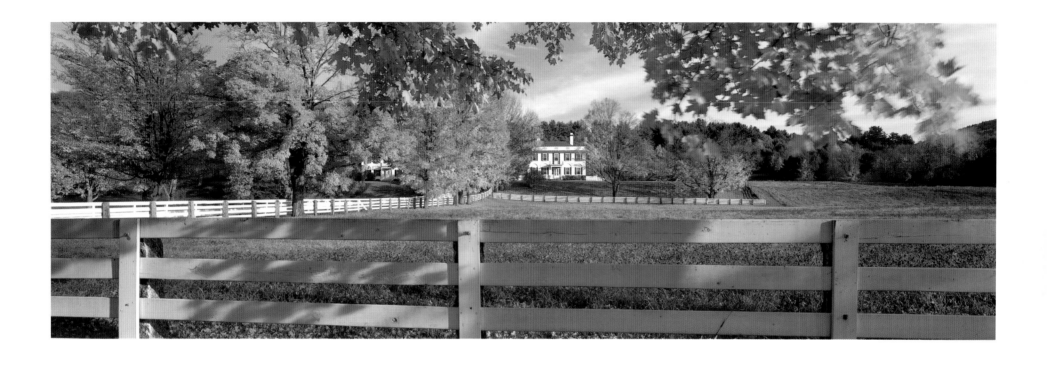

Orford Ridge

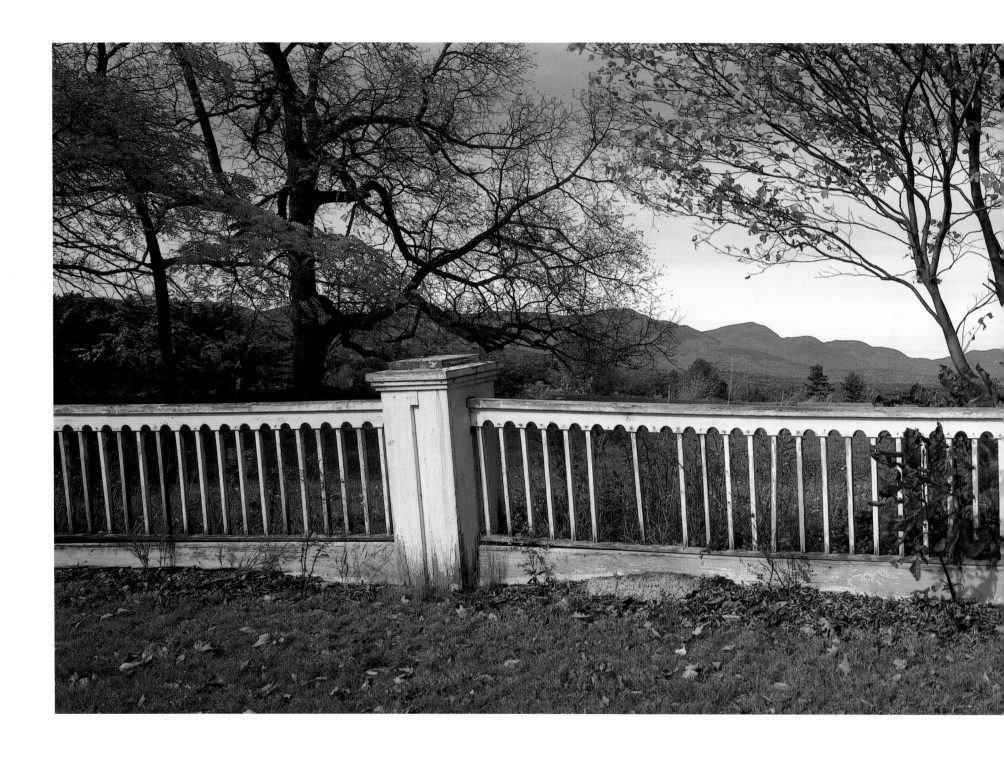

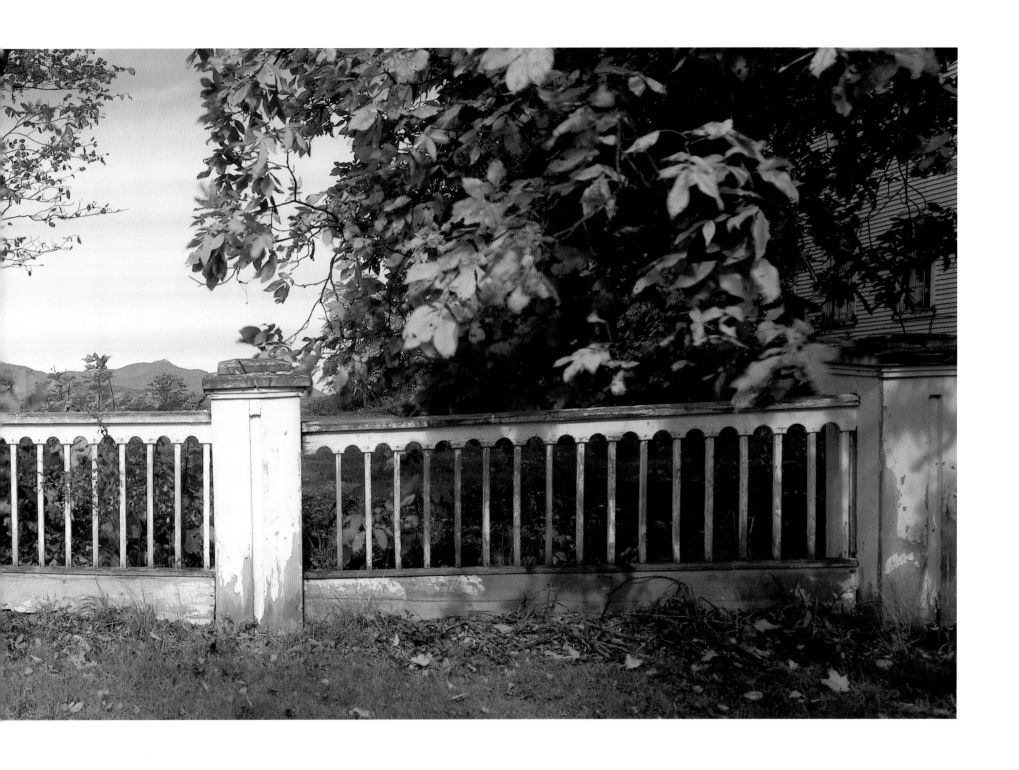

Mt. Chocorua and the Sandwich Range, from Sandwich

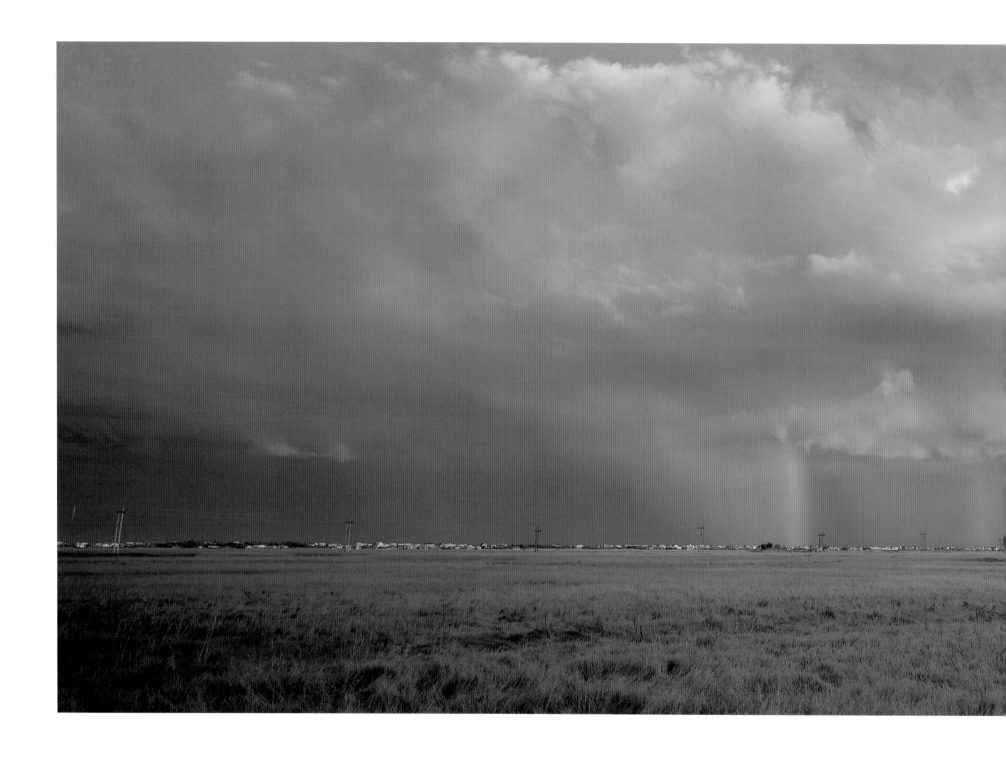

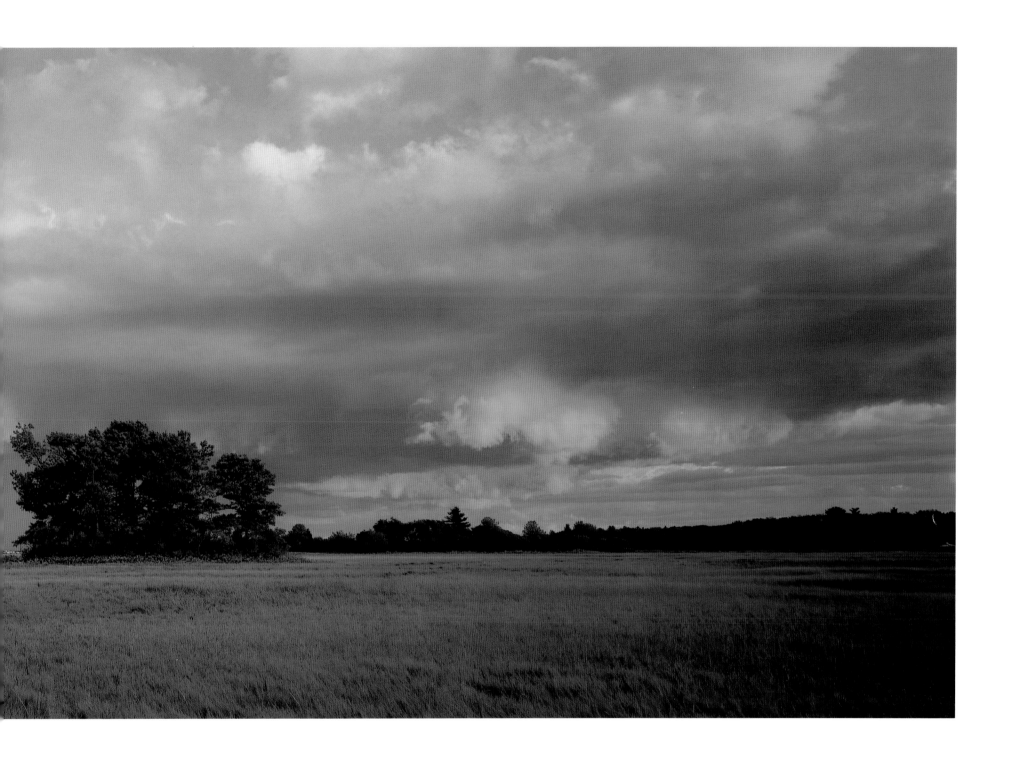

Thunderstorm, Seabrook

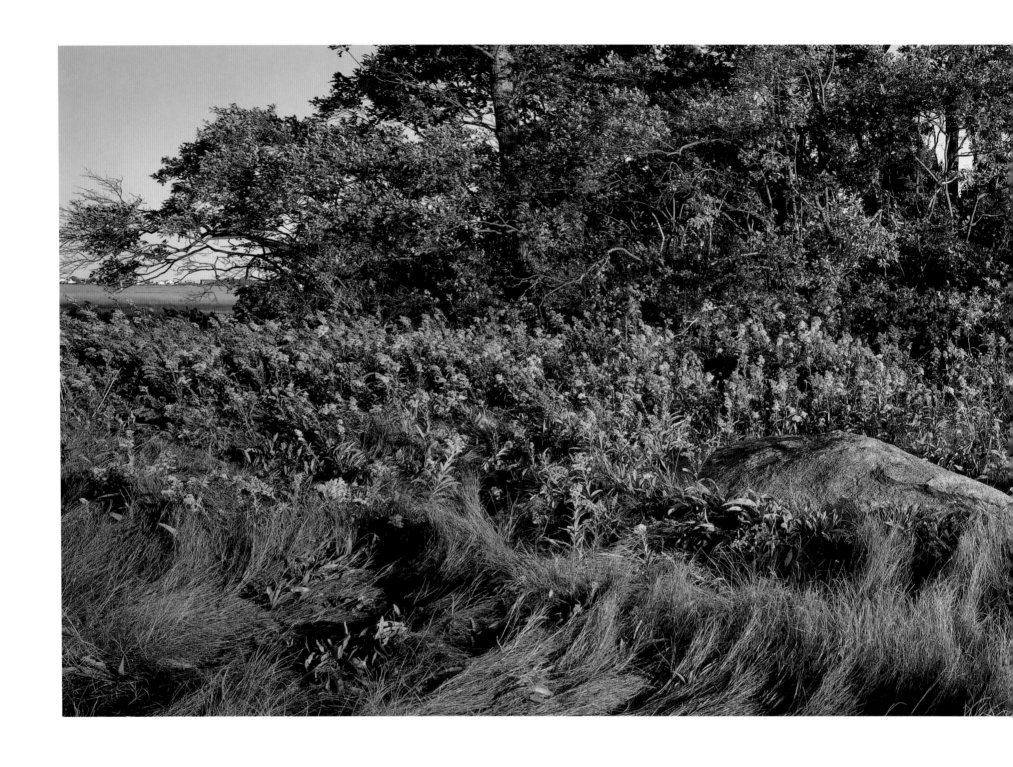

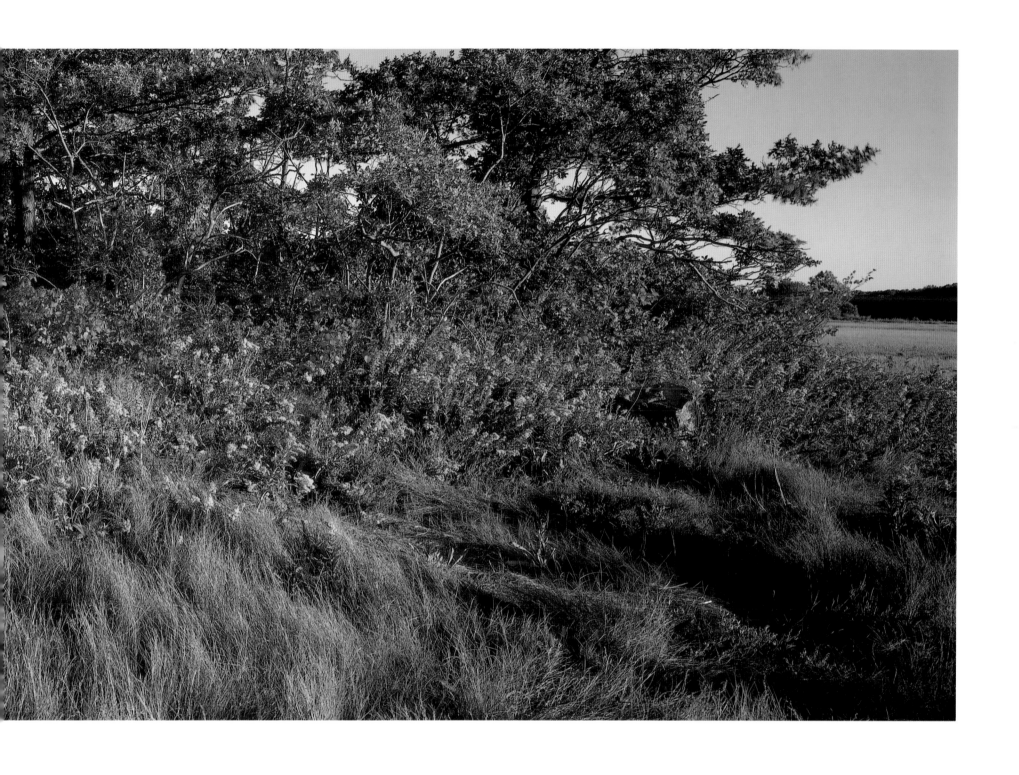

Marsh island, Seabrook

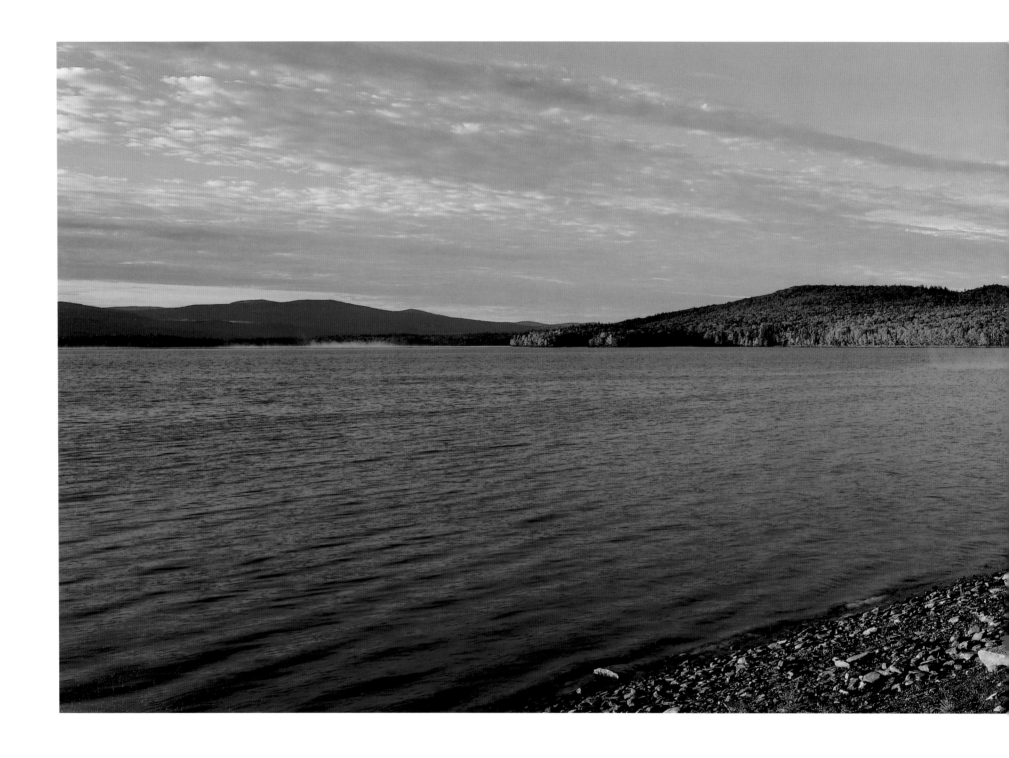

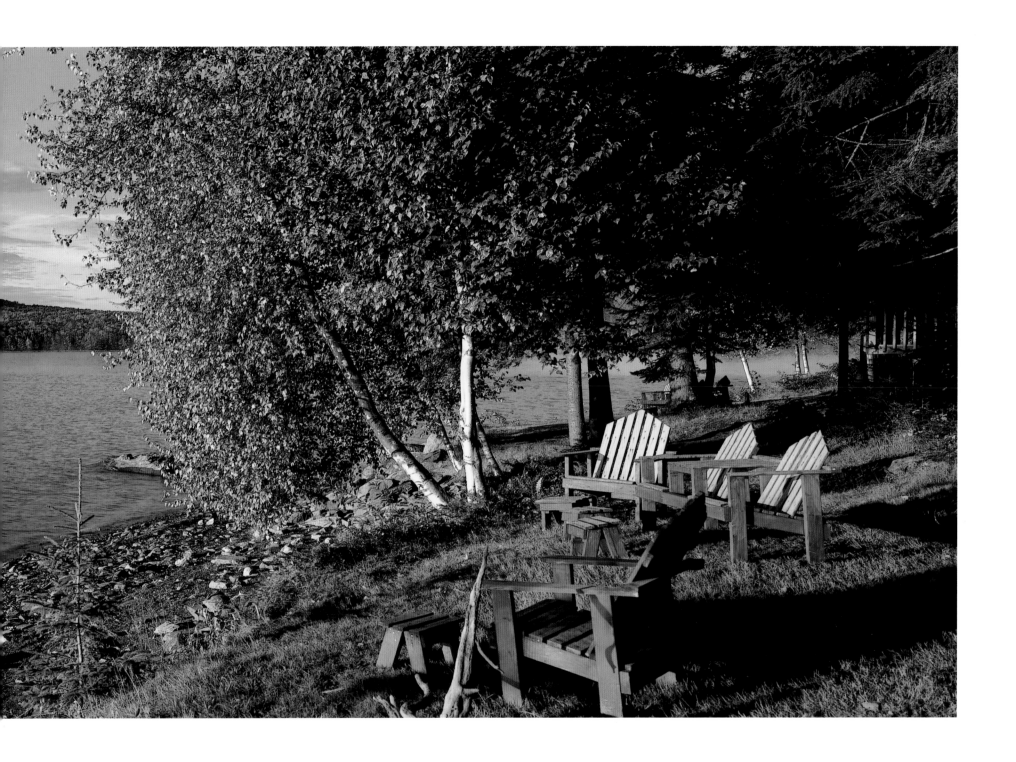

The Glen, First Connecticut Lake, Pittsburg

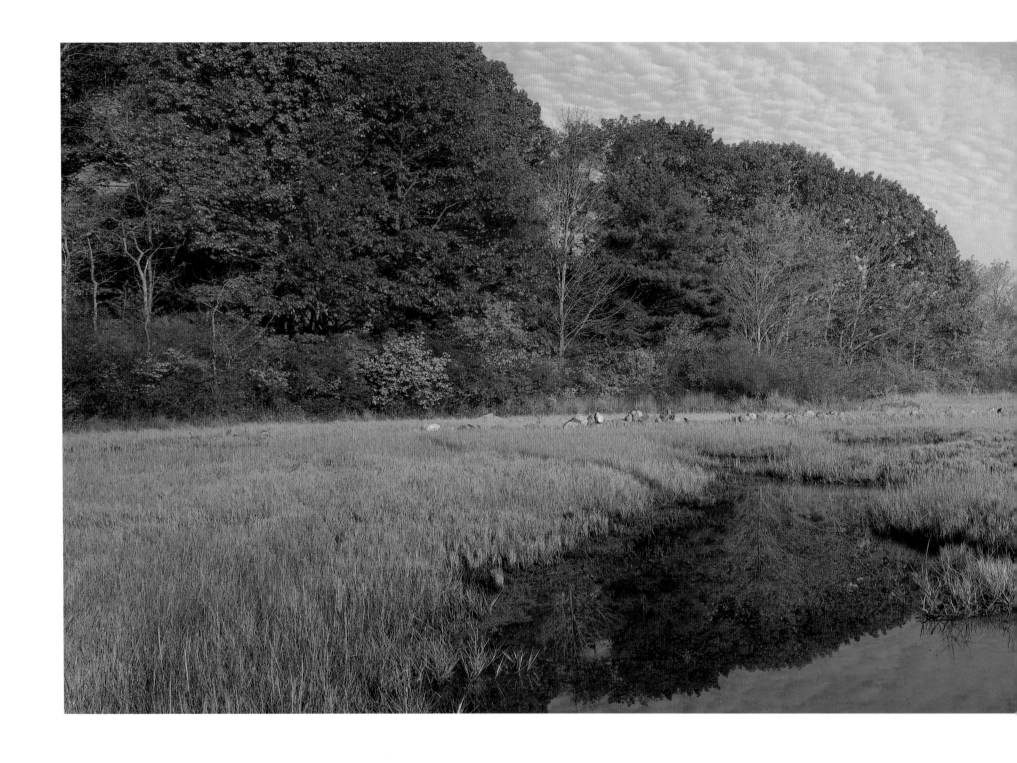

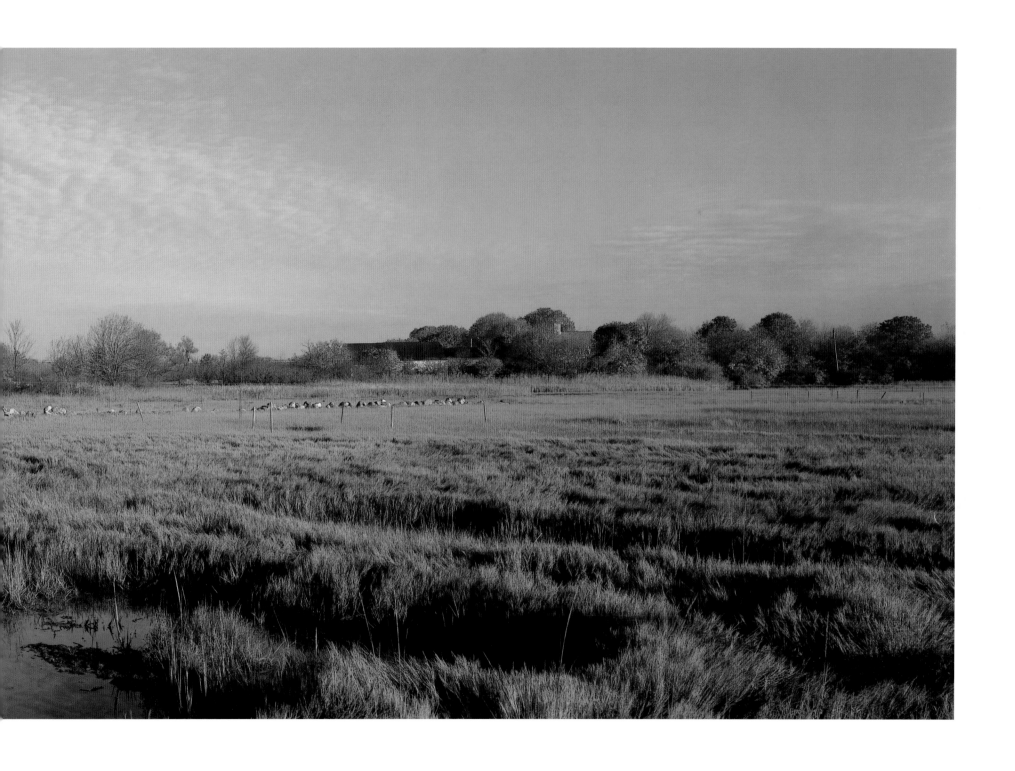

Goss Farm and salt marsh, Rye

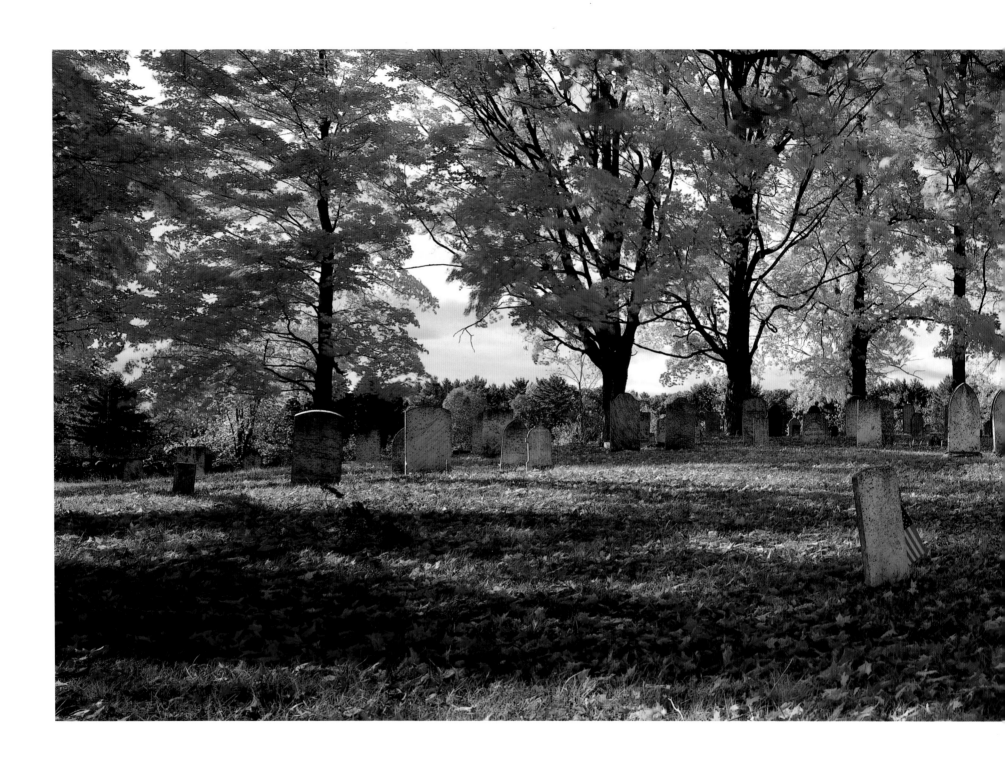

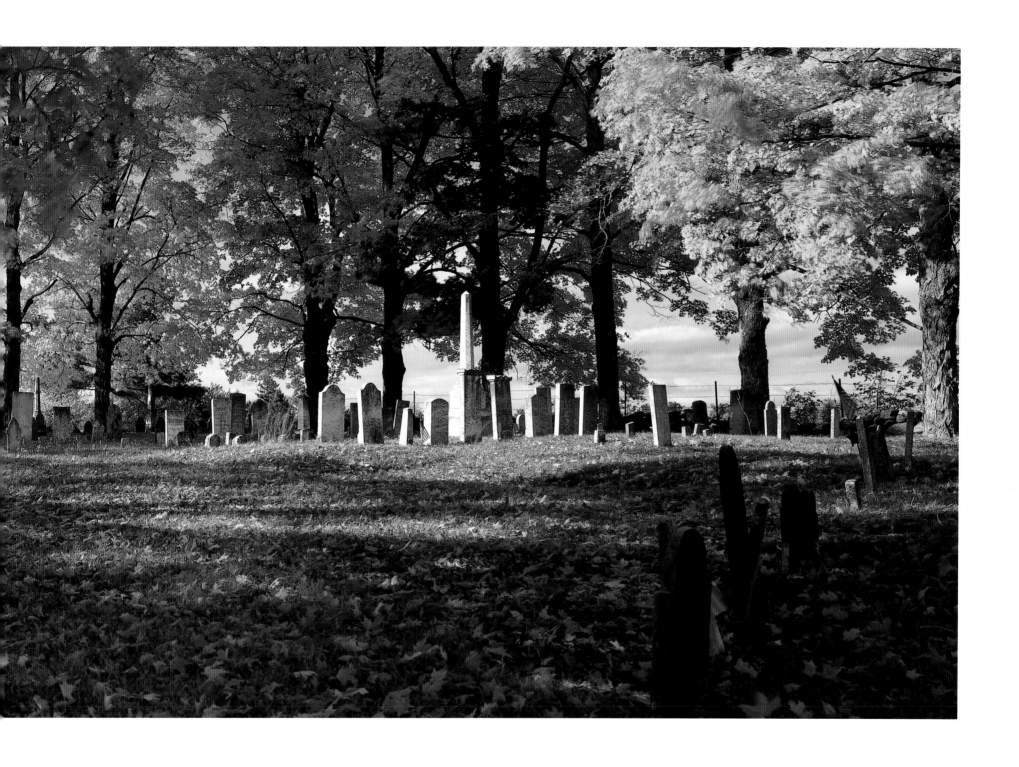

Cemetery, Northwood Narrows

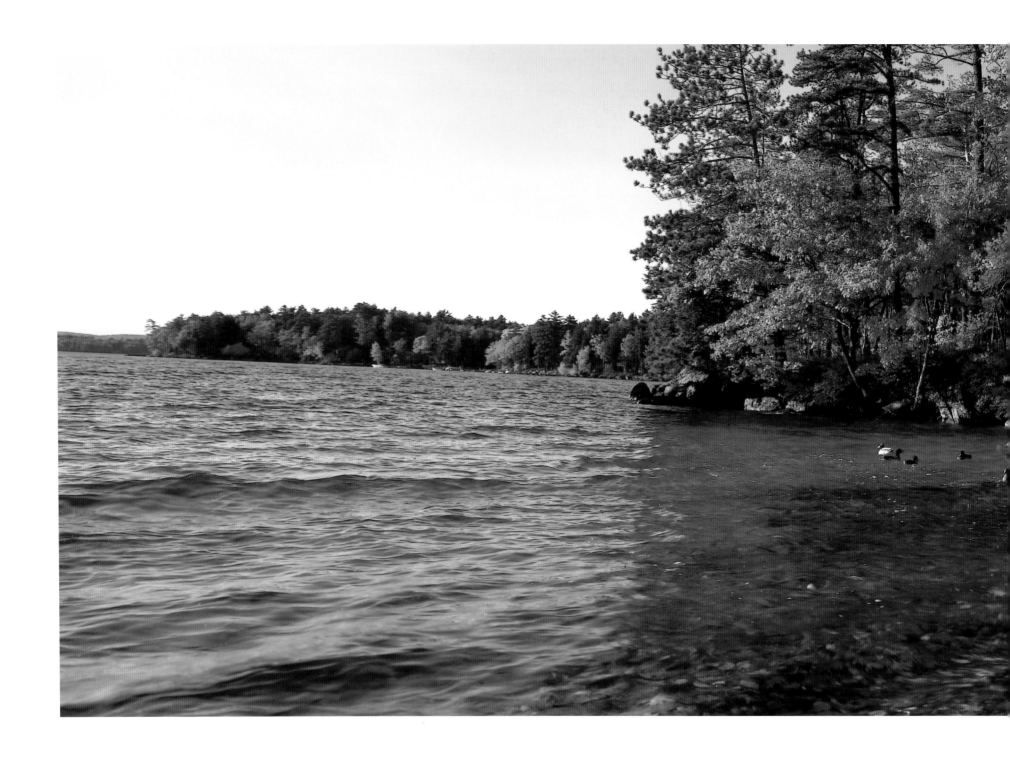

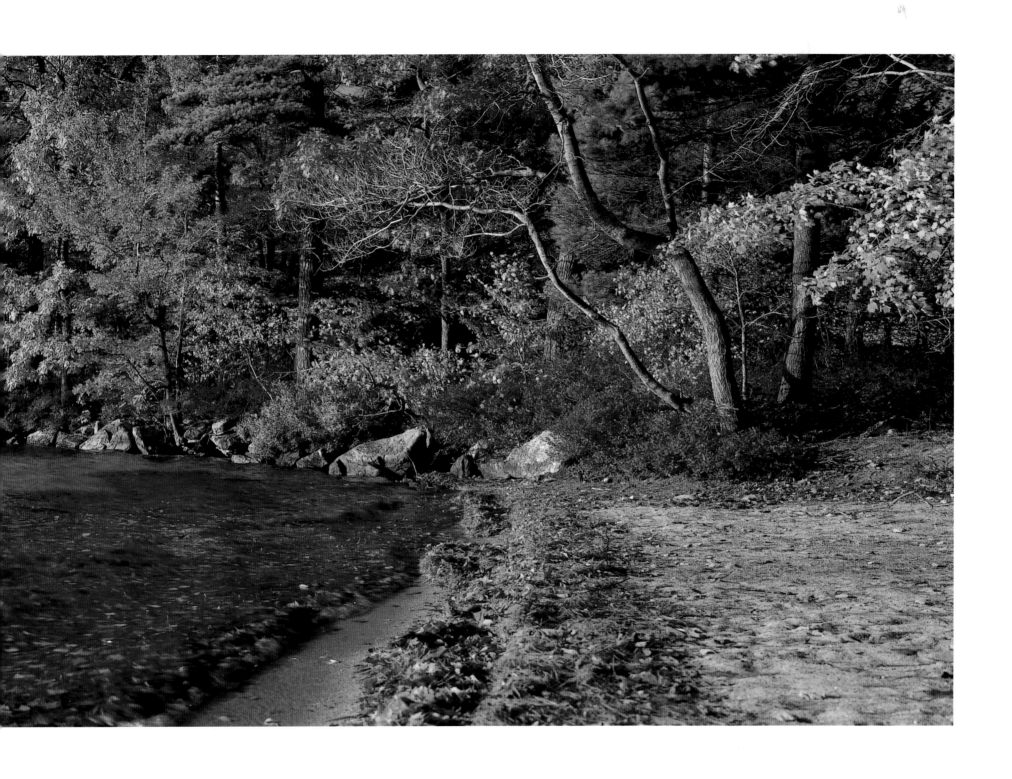

Mallards, Long Island, Lake Winnipesaukee, Moultonborough

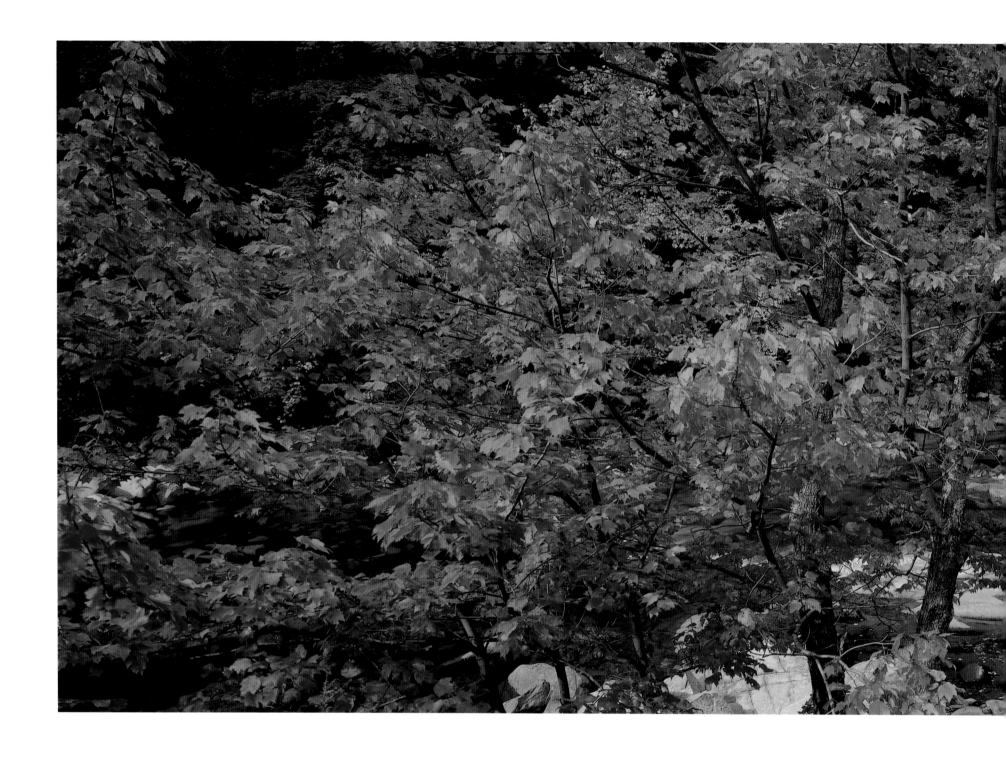

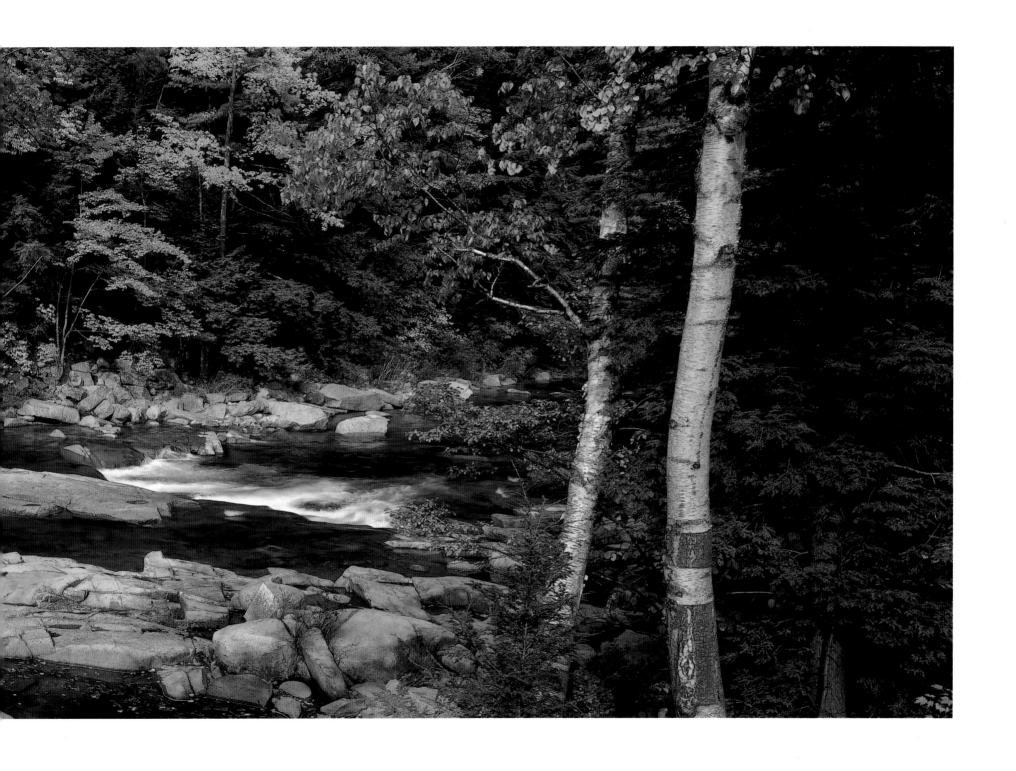

Peabody River, Pinkham Notch

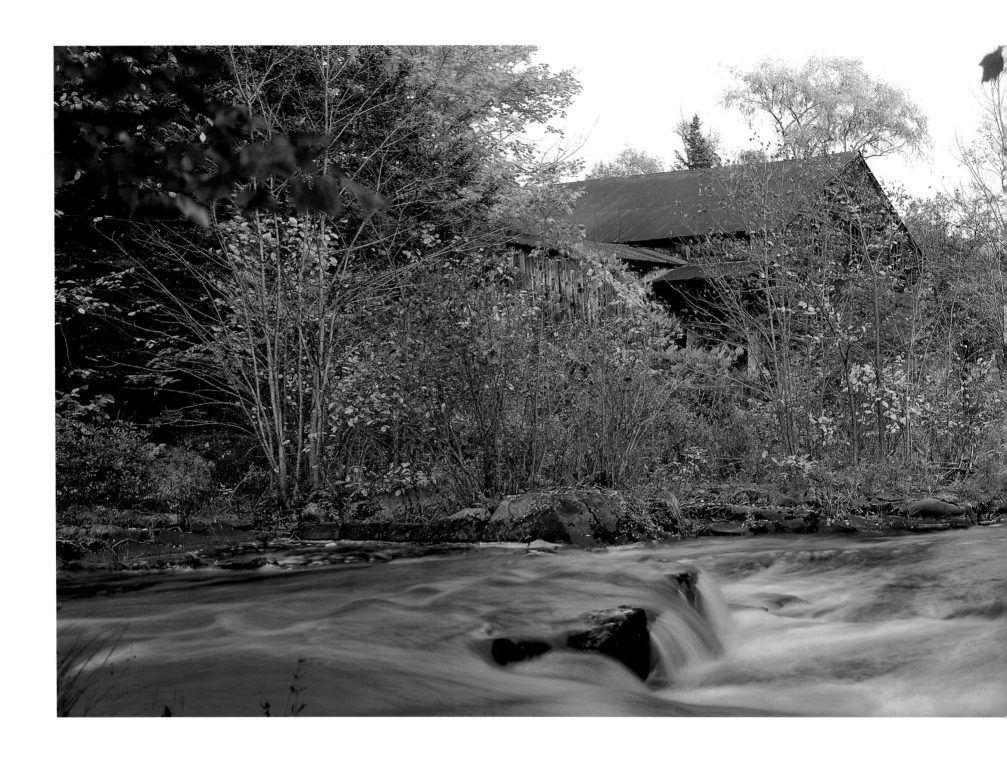

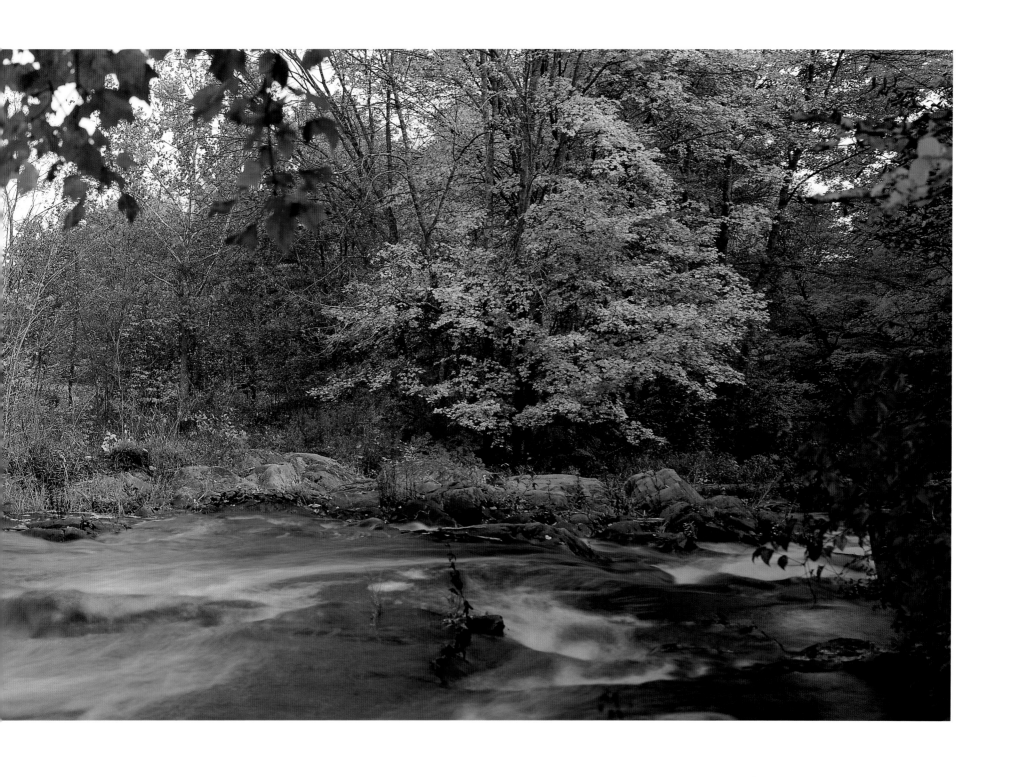

Harvey's Mill, North River, Lee

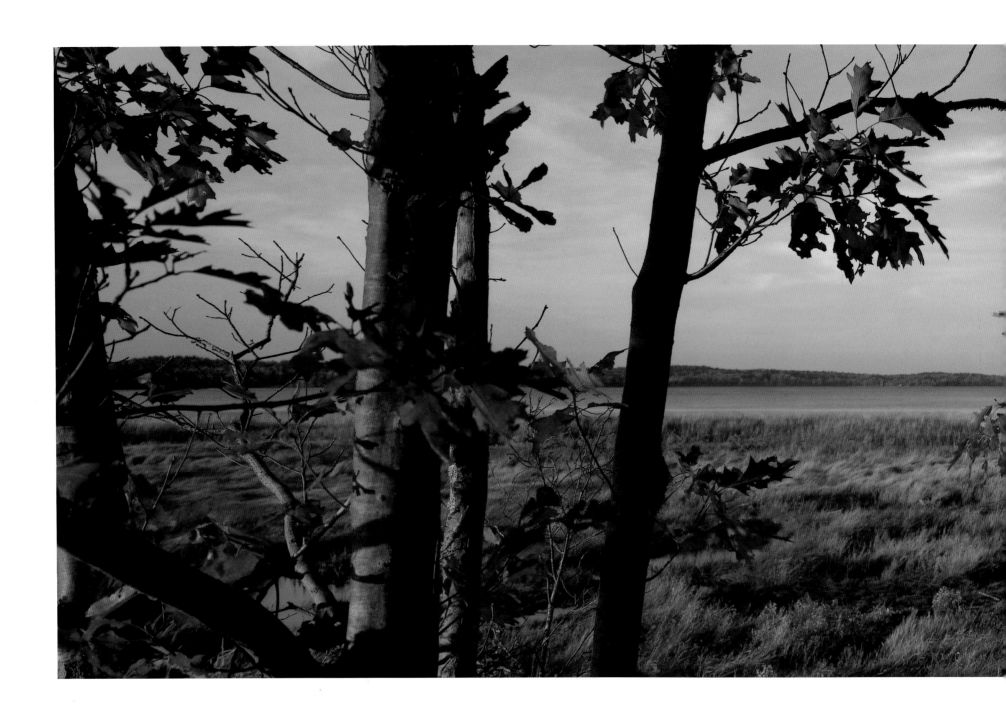

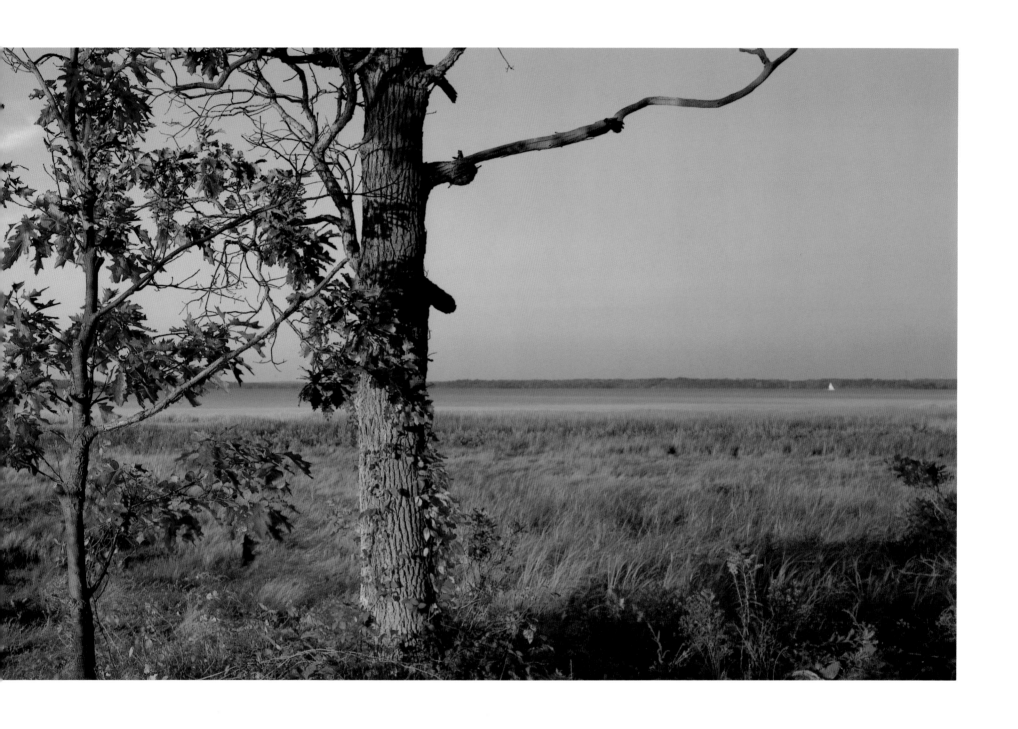

Sandy Point, Great Bay Estuarine Research Reserve, Stratham

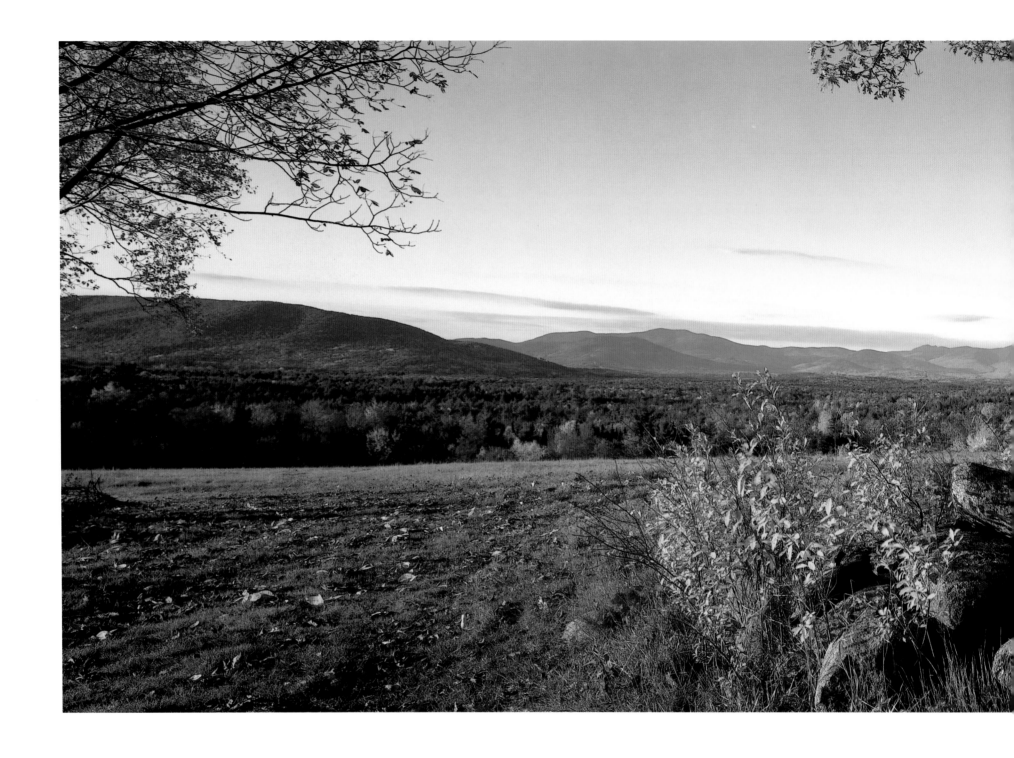

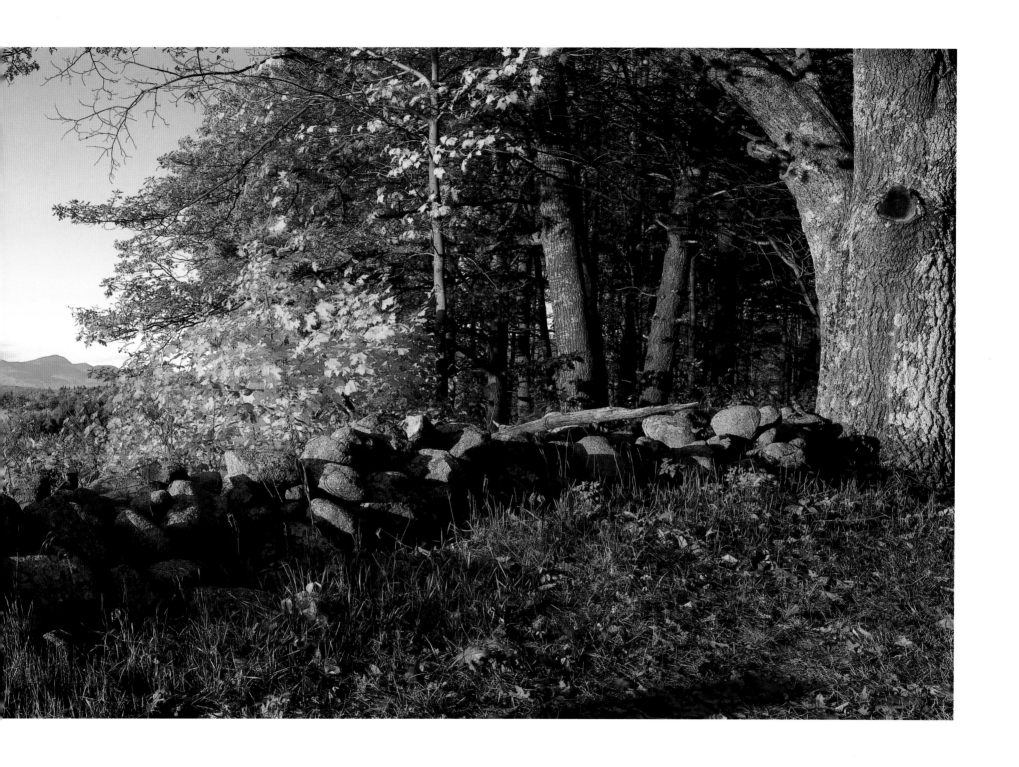

Sandwich Range, from Moultonborough Neck

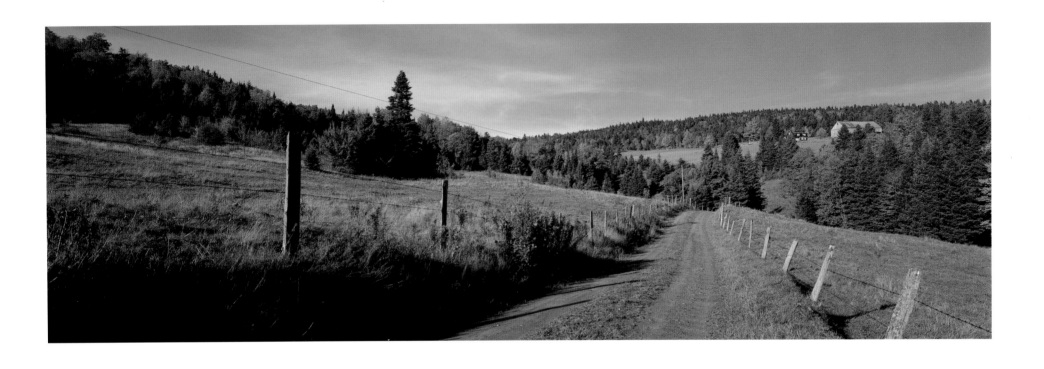

Near Stewartstown Hollow

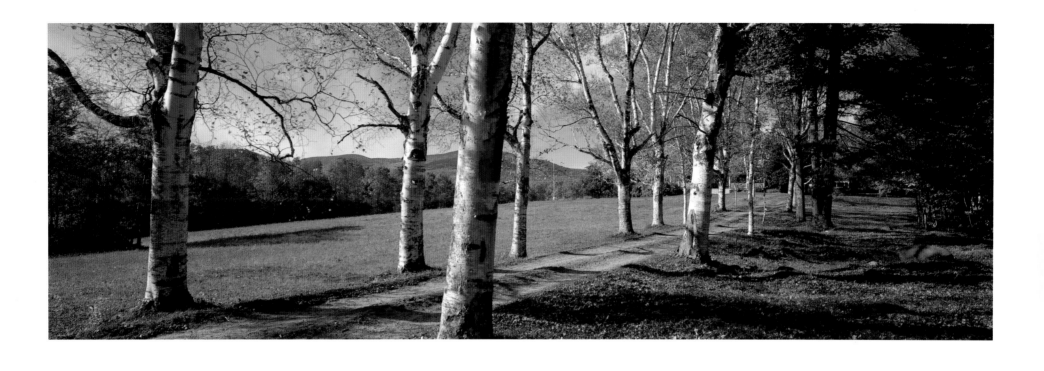

Weed Fields, Sandwich

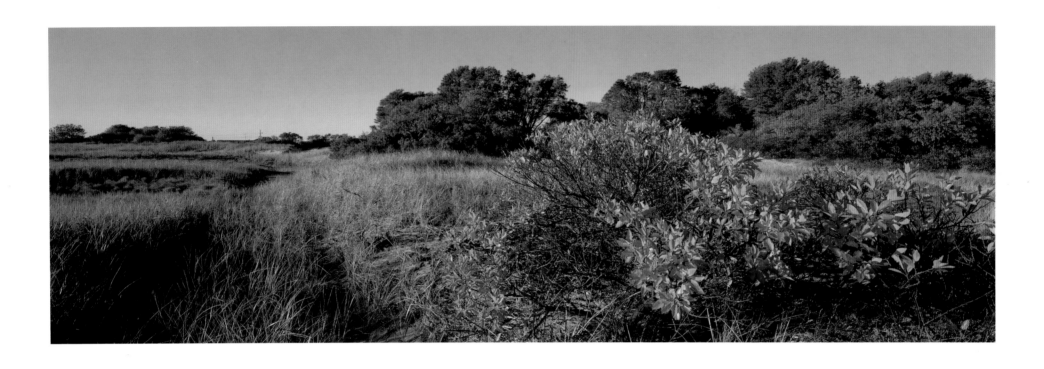

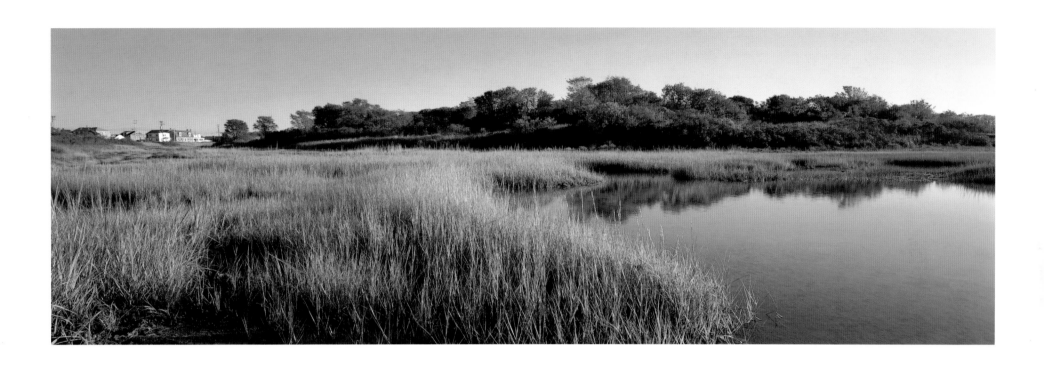

Above and opposite, Seabrook dunes

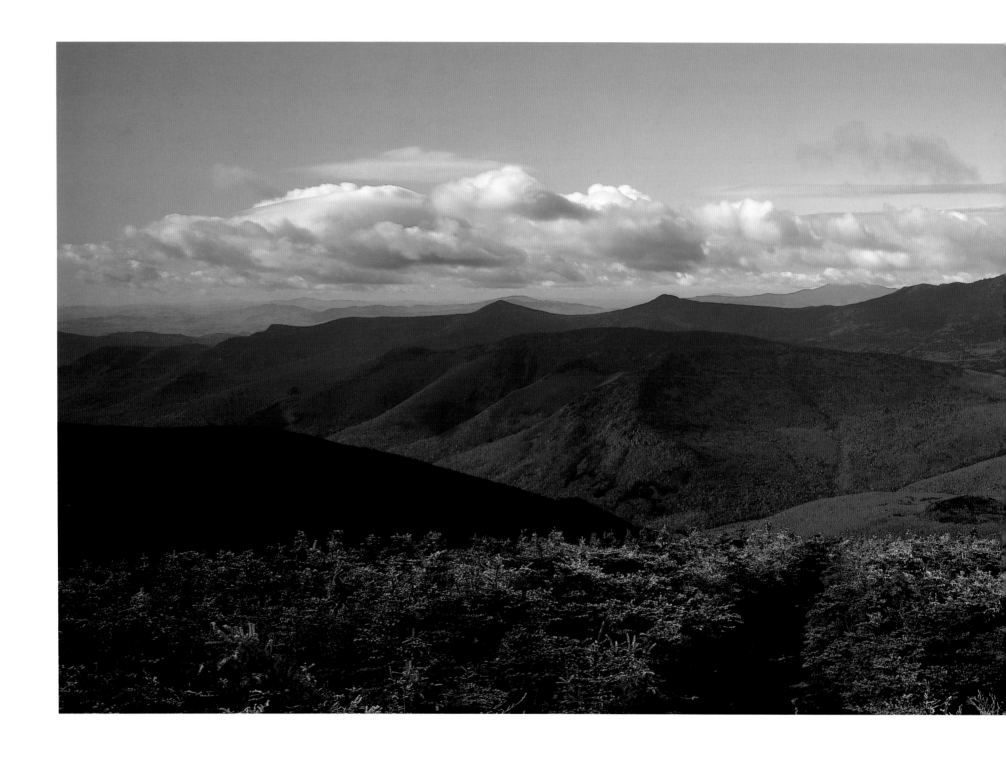

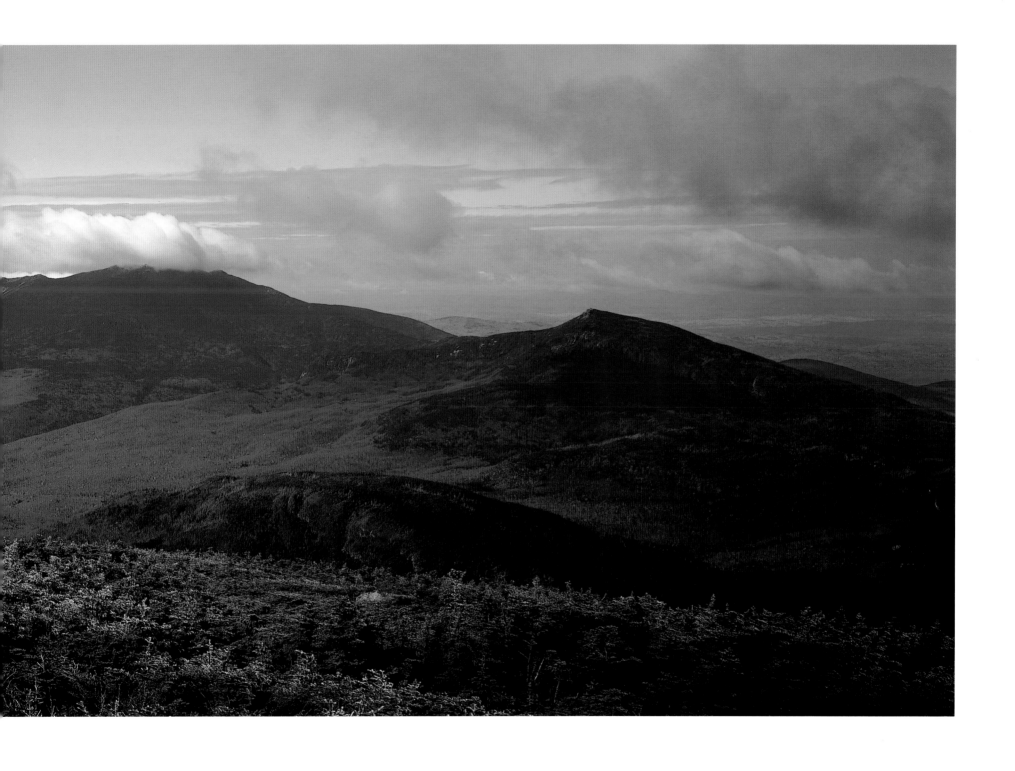

Mt. Lafayette and the Pemigewasset Wilderness, from South Twin Mountain

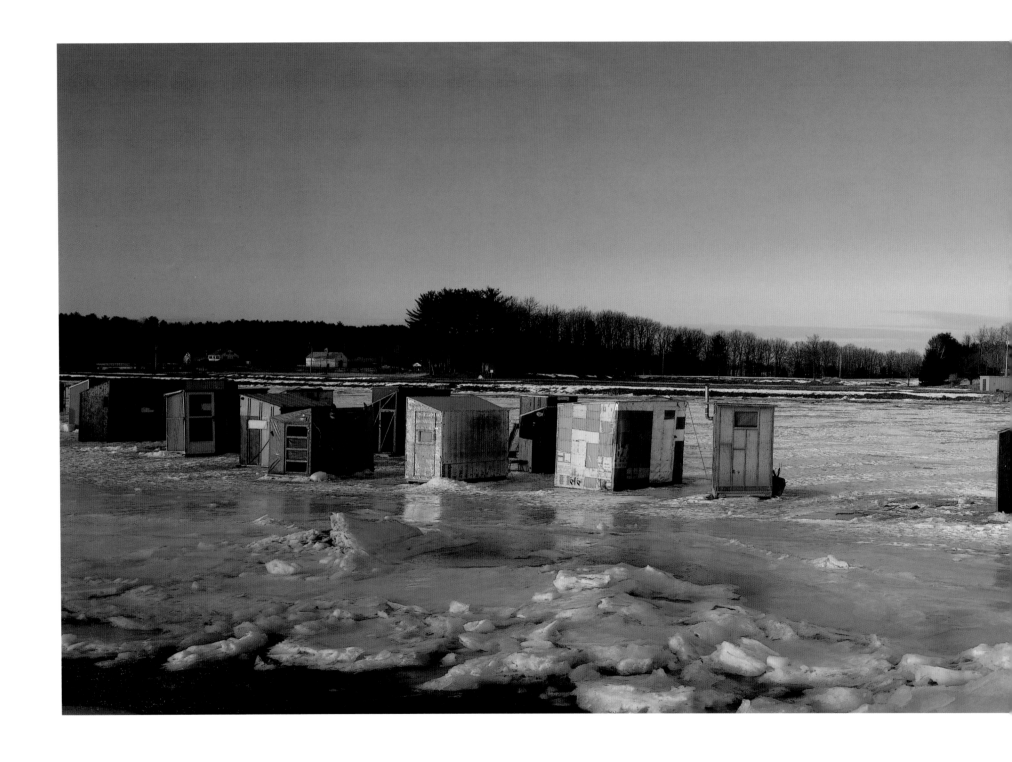

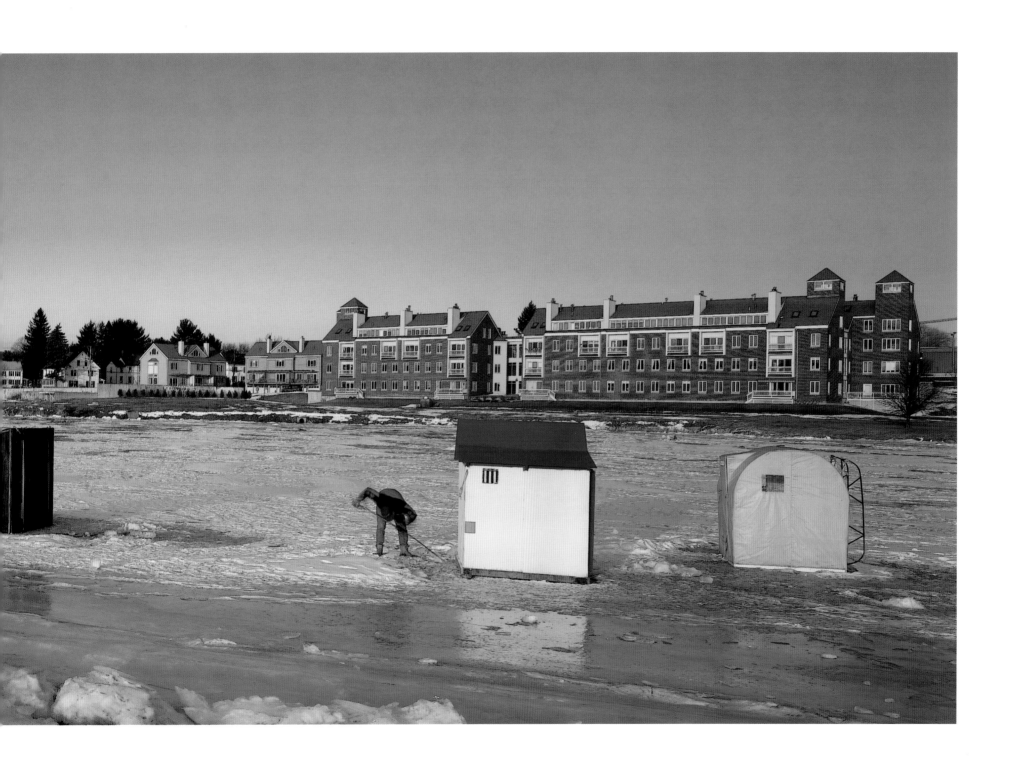

Fish shanties, Squamscott River, Exeter

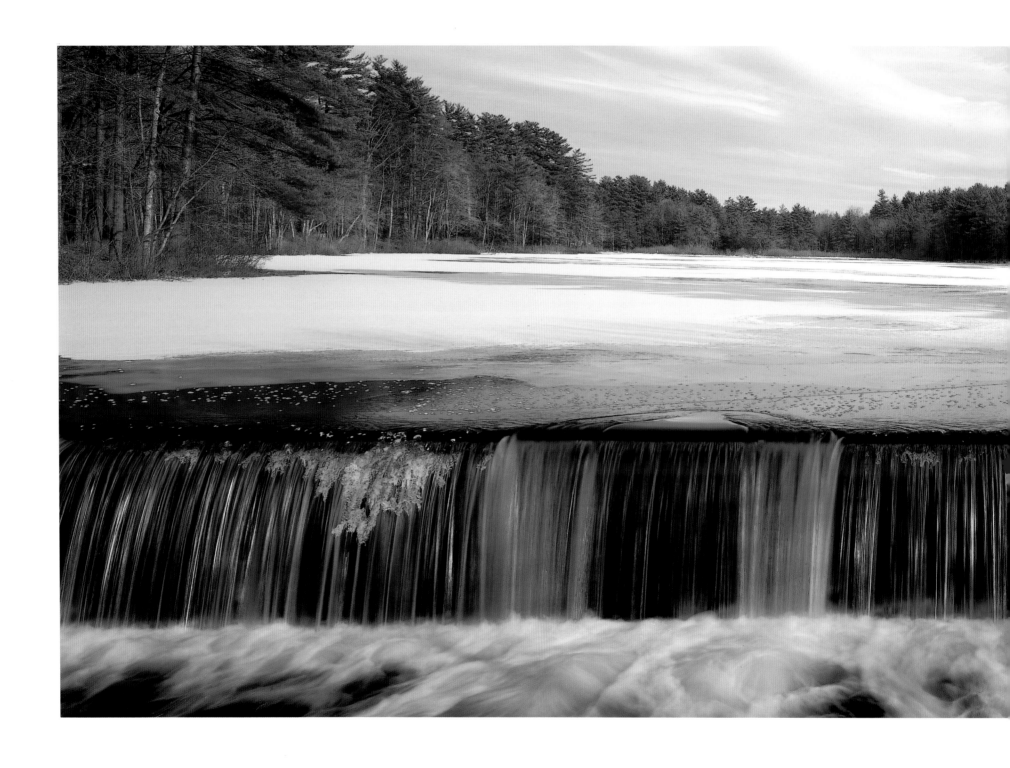

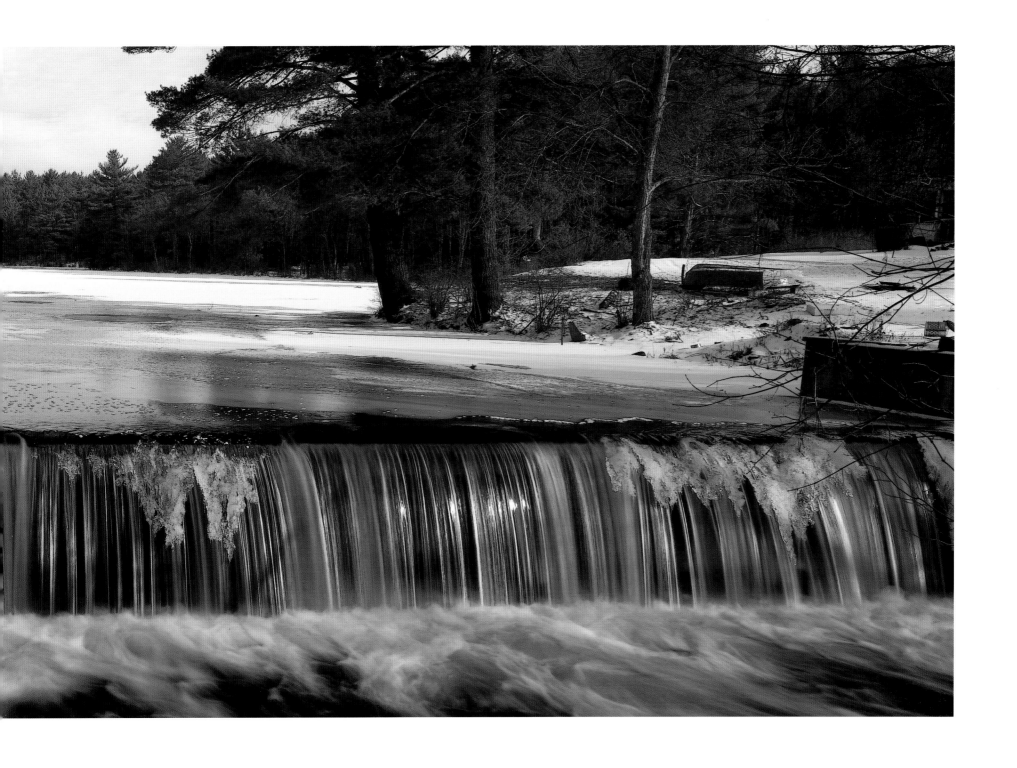

Cass Pond Dam, Epsom

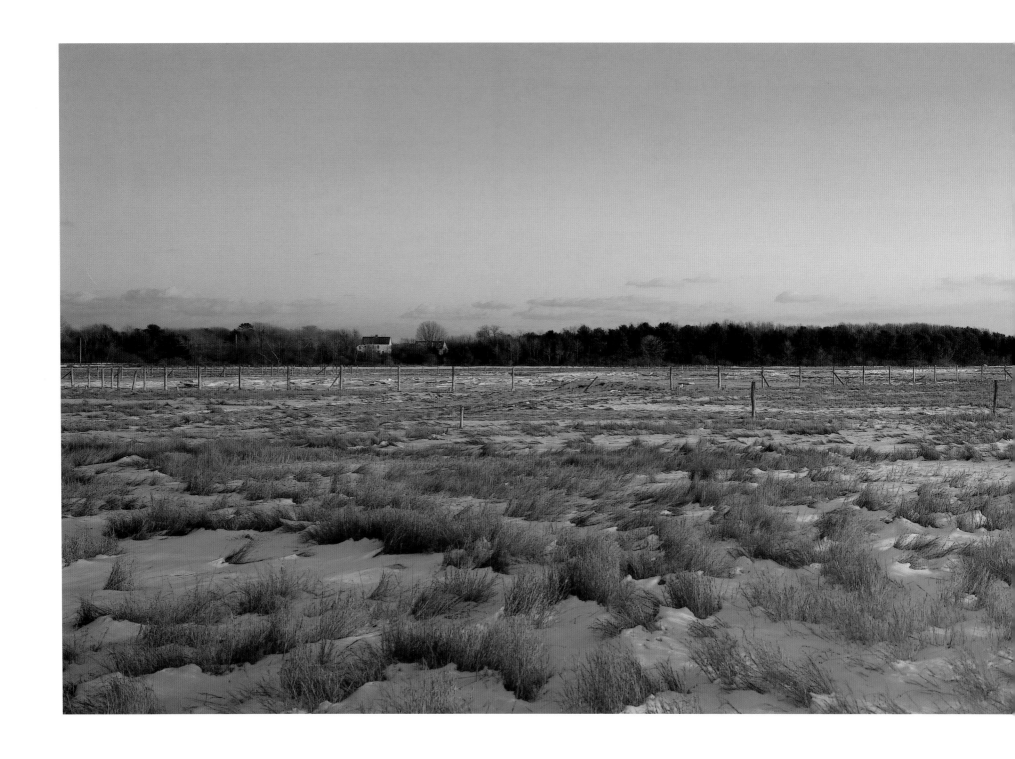

Odiorne Point, site of New Hampshire's first settlement, Rye

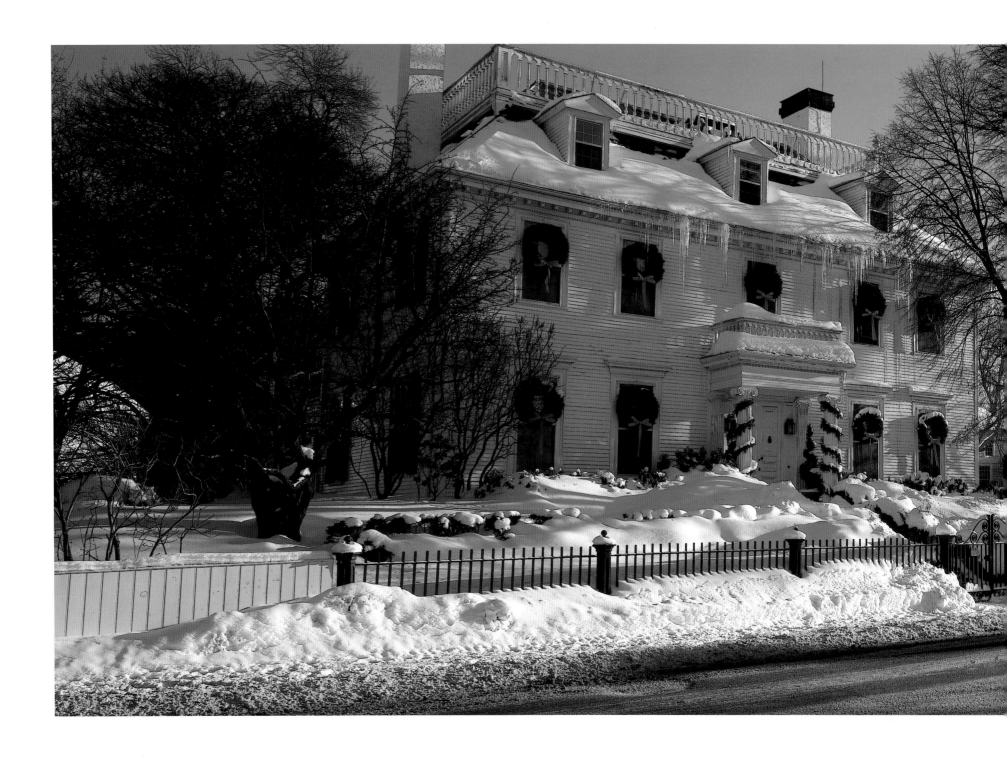

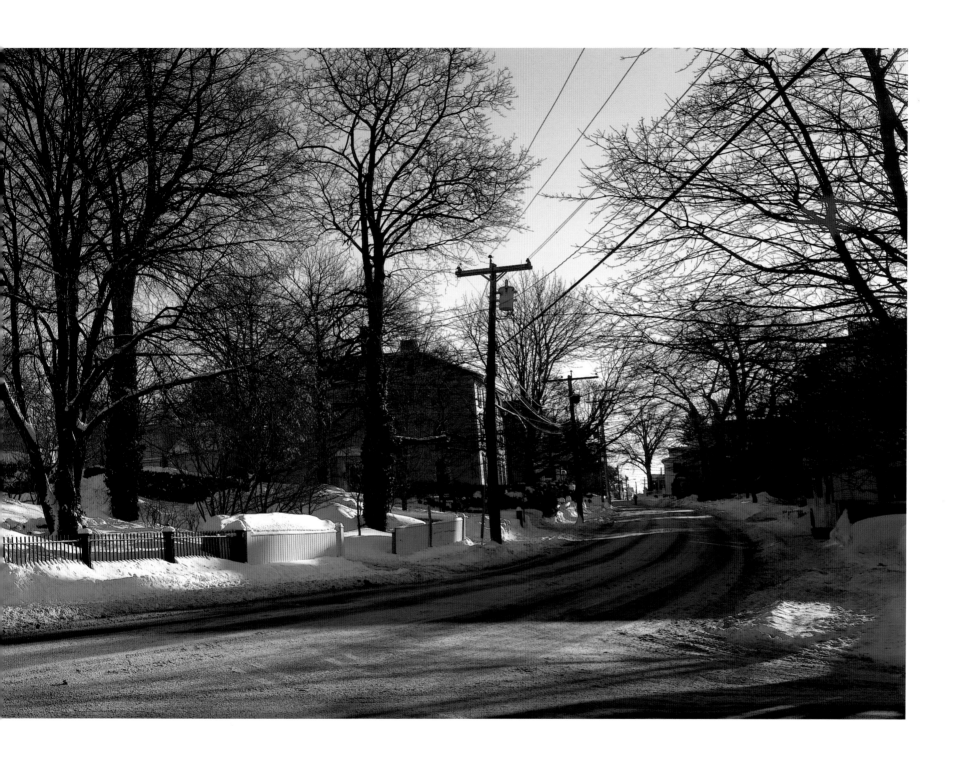

Capt. Thomas Thompson House, Portsmouth

ABOUT THE PHOTOGRAPHER

A twelfth-generation native of New Hampshire, Peter E. Randall graduated from the University of New Hampshire, where he first studied photography with Richard Merritt. Following a journalistic career in newspapers and magazines, he founded a book-publishing house in 1976. Since then, he has produced some 200 volumes, most relating to local history. He is the author of 11 previous books, of which seven feature his photographs of New Hampshire and New England. His photographic journeys to the Southwest, Africa, Spain, Portugal, Italy, and Guatemala have resulted in work exhibited widely in New Hampshire museums and galleries. Randall has received the Granite State Award, given by the University of New Hampshire for contributions to the state, and the Lifetime Achievement Award from the New Hampshire Writer's and Publisher's Project. He and his wife, Judith, live in Hampton.

ABOUT THE PHOTOGRAPHS

I have long been attracted to the panoramic format, but it was only in 1991 that I purchased a Linhof panoramic camera and began to explore the unique perspective that this view provides. Unlike the contemporary, auto-everything, multi-lens, electronic 35mm camera, the Linhof is a rather basic instrument. It requires a handheld exposure meter, and focus is by estimated distance; there is no viewfinder focus. The film format is 120mm, providing four 2 1/4-inch-by-6 3/4-inch exposures per roll. And the camera has only one fixed, wide-angle lens. The result is a slower, more methodical style of photography — a more basic approach reminiscent of the early years of the medium. It is perfectly suited to working in the landscape, to recording a scene much as one sees it with one's own eyes.

— P.E.R.

ABOUT RONALD JAGER

Ronald Jager grew up on a Michigan farm, and earned degrees from Calvin College, Indiana University, and Harvard. He taught philosophy for twelve years at Yale University, and there authored a prize-winning book, *The Development of Bertrand Russell's Philosophy*. For the past fifteen years, Jager has lived and worked in New Hampshire as a freelance writer and consultant. He has served as Program Manager of the State Legislative Leaders Foundation, as Humanities consultant to the New Hampshire legislature, and as frequent lecturer. His numerous essays have appeared in *Harper's, Atlantic, Country Journal, New York Times, Natural History,* and elsewhere; and he has written four books on New Hampshire history. In 1990 Jager, who lives with his wife and son in Washington, New Hampshire, wrote a memoir of his Michigan youth, *Eighty Acres: Elegy For A Family Farm*, which was widely praised. His most recent book appeared in late 1994, a meditation on the history and culture of rural New Hampshire, titled *Last House on the Road: Excursions into a Rural Past.*